THE PERSIS

COLLECTION

of

CONTEMPORARY

ART

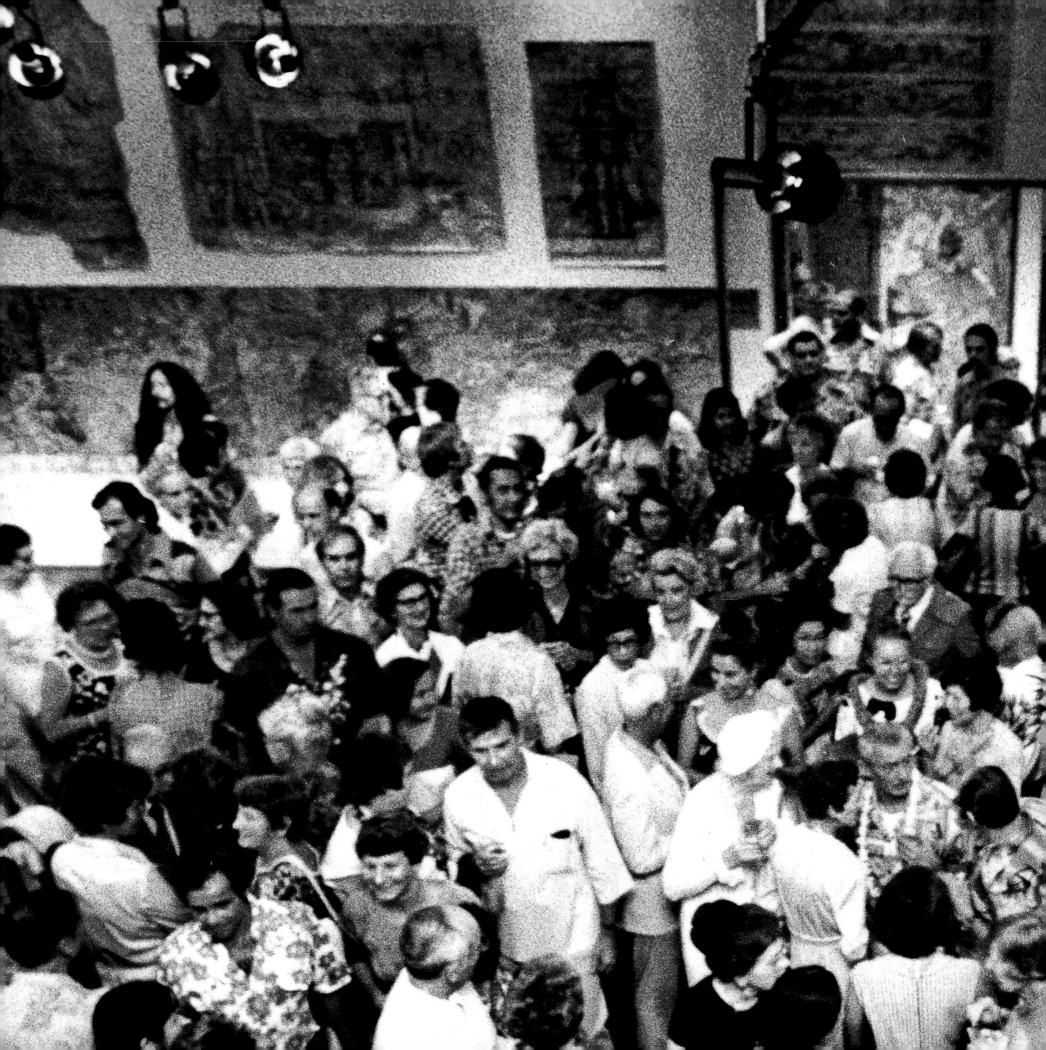

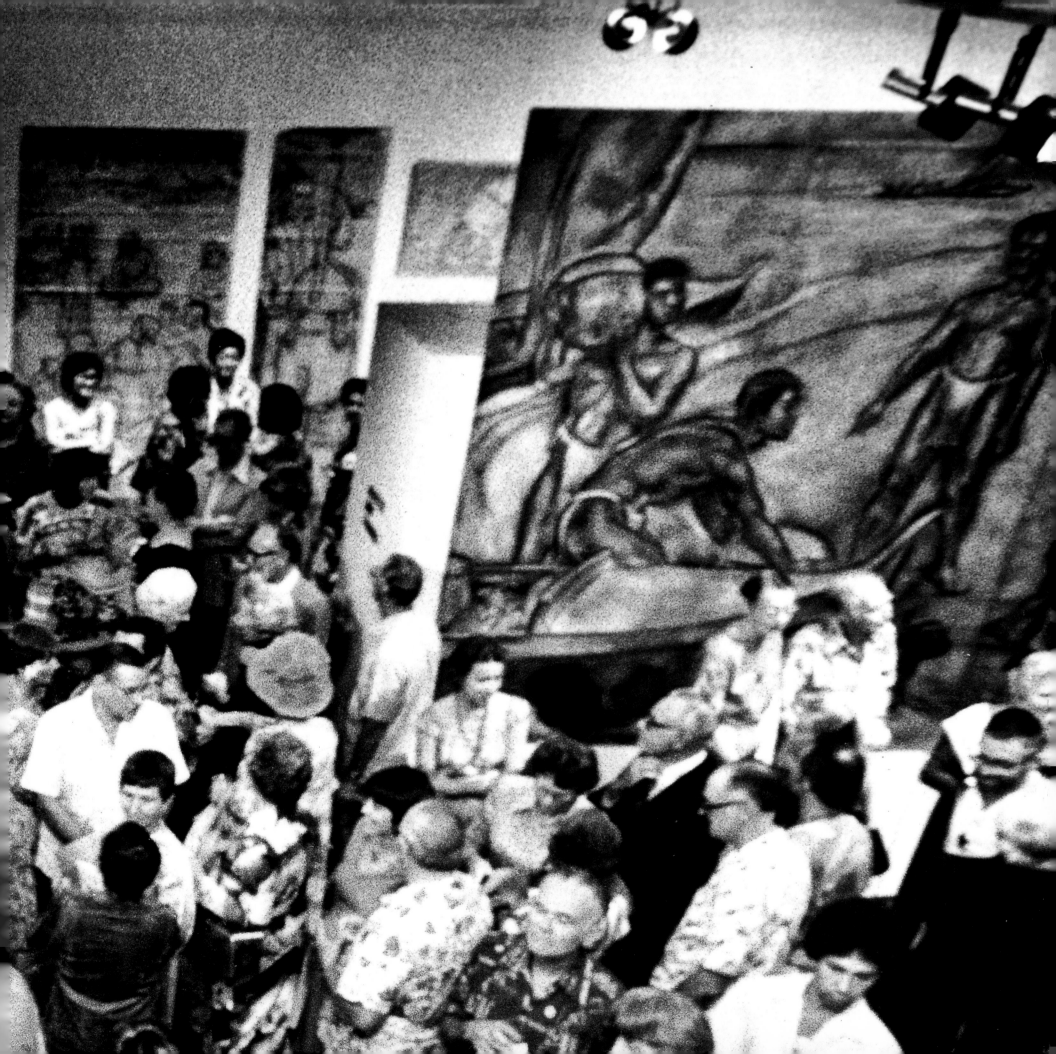

THE PERSIS COLLECTION *of* CONTEMPORARY ART

Goodale Publishing

Honolulu, Hawaii

THE PERSIS COLLECTION OF
CONTEMPORARY ART

Copyright © 1998 Goodale Publishing

A *History* copyright © 1998 Jocelyn Fujii

Photograph credits, page 109

Published by

GOODALE PUBLISHING

Honolulu, Hawaii

Library of Congress Catalog
Card No. 98-67184
ISBN 1-892752-00-x
First Printing August 1998
First Edition

Printed in Hong Kong

Edited by Grady Timmons
Design by Bud Linschoten

Contents

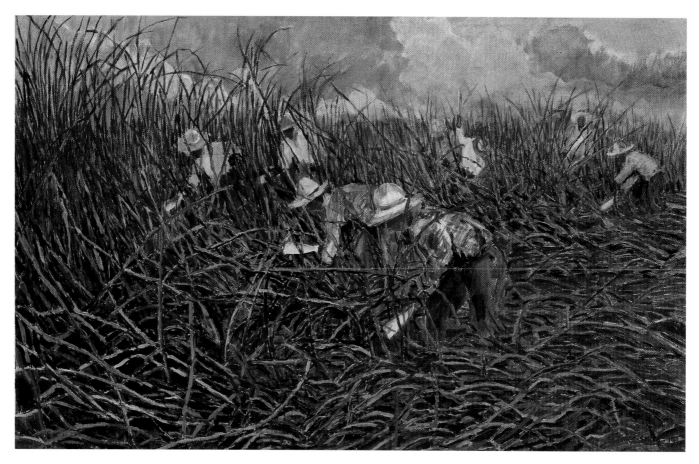

William Twigg-Smith: CANE HARVEST, *oil on masonite, 1940*

Prologue

The elapsed time—from suggestion of an exhibition art gallery in the News Building to its approval—was a matter of seconds. Admittedly it was a great idea, but how did it get such rapid approval? The answer lies in my being raised in a family headed by an artist: my father, William Twigg-Smith.

Our home on Bates Street, which he built himself, was filled with art. Most of it consisted of landscapes he had done throughout the Islands, but there were pieces from friends of his, most notably a large Charles W. Bartlett that hung in the living room opposite the fireplace.

My father had come to the Puna district of the Big Island in 1916 to make Hawai'i his home after graduating from the Chicago Art Institute. At the turn of the century, at age sixteen, he had left his native New Zealand to study art in San Francisco, where he survived the 1906 earthquake and fire. Along with other former residents of New Zealand and Australia, he was evacuated from San Francisco and returned to his homeland. He didn't remain long and returned to America, passing through Hawai'i for the third time, no doubt crystallizing his desire to make it his home.

He displayed and sold his early paintings in Hilo and at Volcano, where, in 1917, he met the lady who was to become my mother. After serving in France in World War I (by which he gained his American citizenship), he returned to Honolulu and married that lady, Margaret Thurston. He then built the house and a studio and carpenter shop in the pasture of my grandparents' large lot on Bates Street, and set about being a professional artist. If there had been gallery space like the News Building, he might have made it.

In addition to the challenge of selling art, I had come along a couple of years later, followed by my sister, Barbara, and brother, David. An artist's income was not a steady source of funds to support a family of five in those days in Hawai'i, and in the mid-1920s he became an illustrator for the Hawaiian Sugar Planters Association, a job he enjoyed and continued until his retirement in 1946.

My father's studio on Bates Street continued to grow, eventually becoming part of a big structure he built, encompassing the studio, a two-car garage, a storage room, a carpenter shop, and a three-bedroom apartment over the garage and carpenter shop. He painted on weekends and was most prolific during the three-month vacations the HSPA

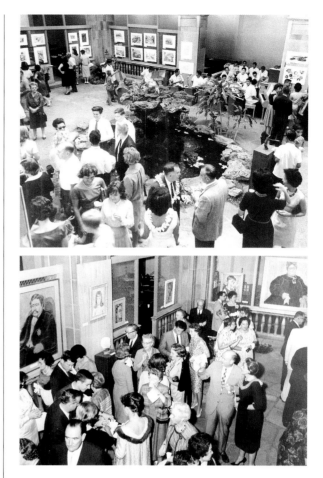

Top: The Contemporary Arts Center in its early days: a gathering place for Hawai'i artists, whose works were displayed around the ground-floor courtyard of what later became known as the News Building.
Bottom: The Madge Tennent portrait show in March, 1962, draws more than 1,000 art lovers to the gallery.

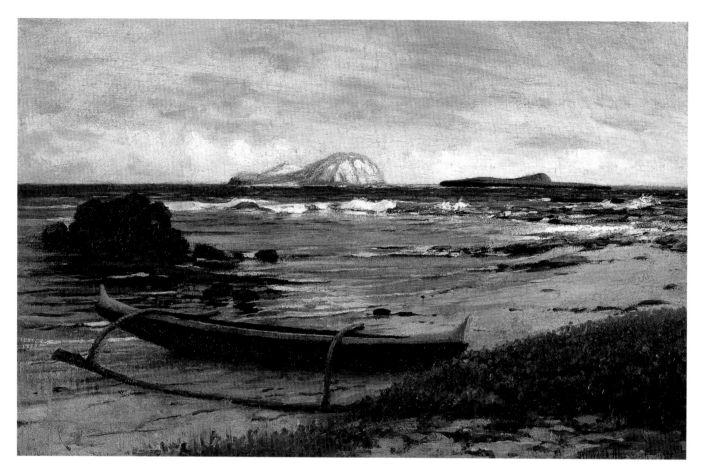

David Howard Hitchcock: UNTITLED, *oil on canvas, 1929*

gave its employees every three years. We loved the studio with its 20x36-foot space, its 18-foot vaulted ceiling, its big easel, its high walls covered with paintings. We and other kids from the neighborhood spread out our electric train sets during Christmas vacations and always, there was the smell of turpentine.

With these memories, when Dick Habein and David Asherman came back from lunch one day in 1960 to suggest we convert the central courtyard of our building into a gallery, I didn't need to think about it at all. "Great idea," I said, and we went right ahead. It was going to be run by volunteers and built from contributed materials, so there was no significant budget problem.

I think the decision to buy at least one piece out of every show was just as easy. Collectors have this inborn thing about seizing advantages like that. There was a budget problem here, though, and we could get corporate funds enough only for a Tadashi Sato from the first show, which also featured Bumpei Akaji. My wife and I bought a small Akaji on our own, though, and couldn't resist future shows as well.

That's how it all began.

Thurston Twigg-Smith
Honolulu, 1998

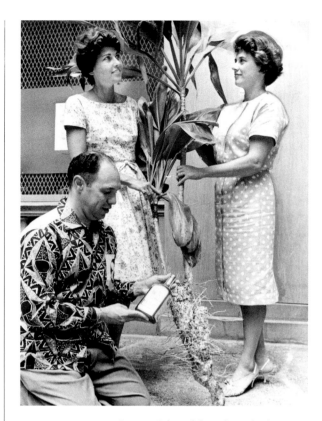

George Pali and friends ready the okolehao and ti plant for an October 1962 exhibition of paintings by Louis Pohl and sculptures by Fritz Abplanalp.

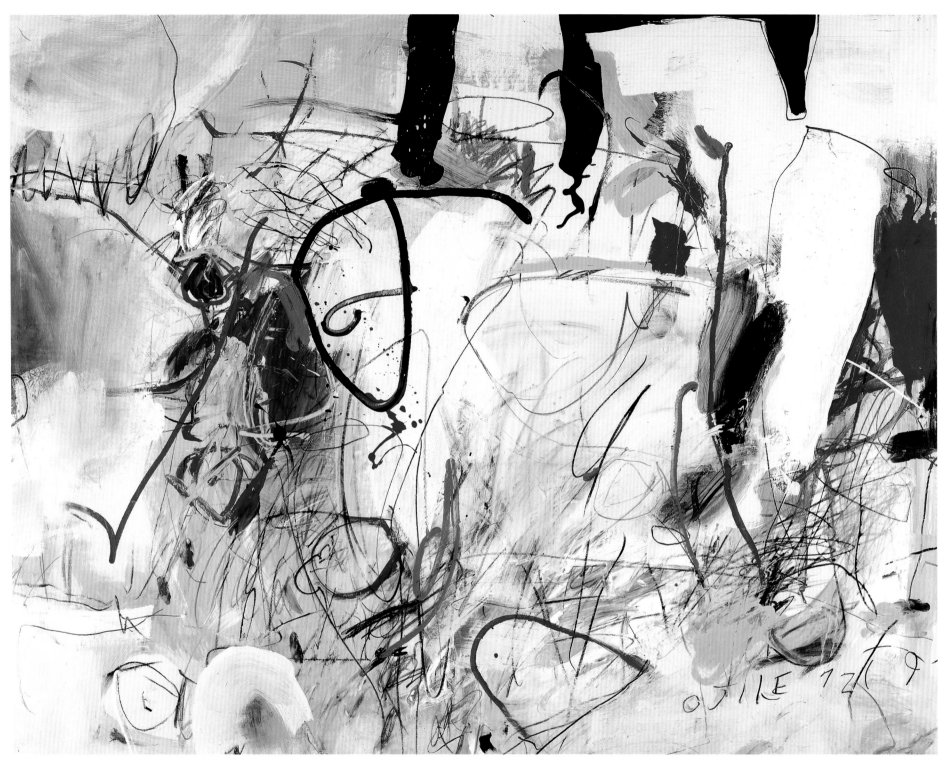

Timothy Ojile: UNTITLED, *acrylic, pencil, and crayon on paper,* 1992

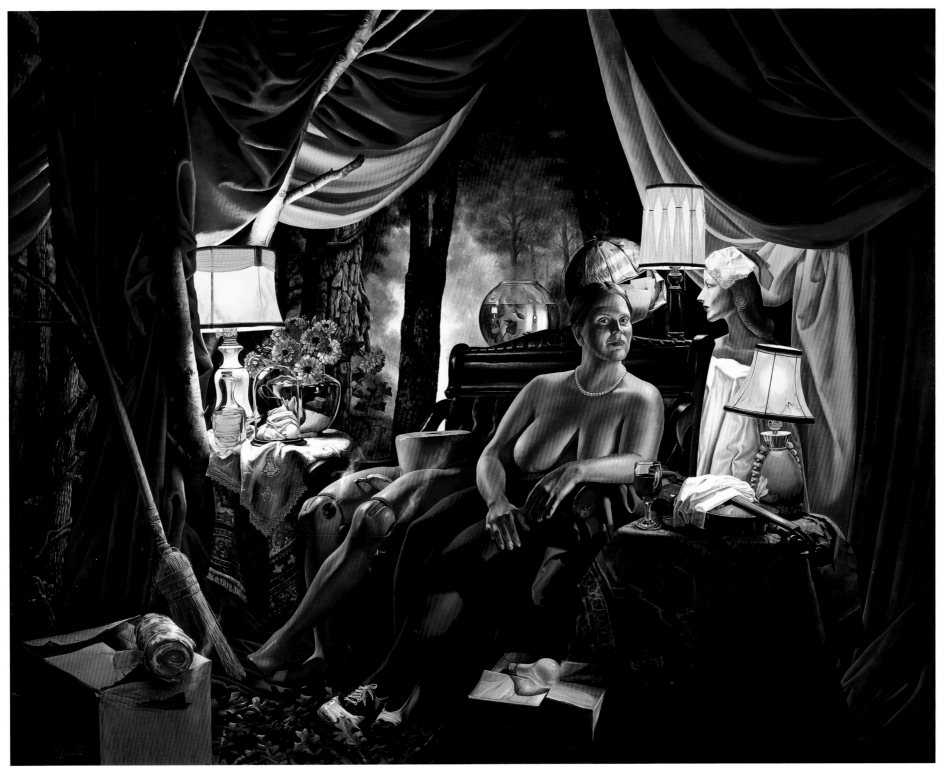

Donald Roller Wilson: THE ROAST IS RESTING, *oil on canvas*, 1976

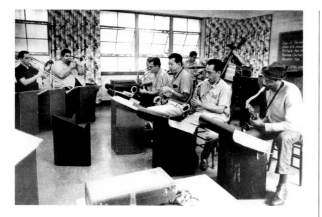

The Contemporary Arts Center sponsors "The Headliners," a jazz band composed of some of Hawai'i's finest musicians.

Introduction

In the summer of 1998, Persis moved its corporate offices from the News Building on Kapiolani Boulevard to a remodeled historic house in Makiki Heights just mauka of The Contemporary Museum. The move marked the end of an era. Representing the Twigg-Smith family of shareholders, we at Persis Corporation wish to commemorate, with this book, the closing of an important chapter in Hawai'i's history. Persis Corporation is proud to present the story of its gallery and the people who contributed to it: memories of a place that had a major influence in the shaping of contemporary art in Hawai'i.

The Persis Collection has been known variously as The Honolulu Advertiser Gallery (at its founding in 1961); the Contemporary Arts Center (from 1975); and, following the opening of The Contemporary Museum in 1988, The Honolulu Advertiser Collection. Finally, since the sale of *The Honolulu Advertiser* newspaper in 1993, the collection has been known as the Persis Collection. All these monikers refer to the collection that resulted from a gallery started in 1961 by Thurston Twigg-Smith, at the suggestion of David Asherman, a Hawai'i artist, and Dick Habein, assistant promotions manager at the *Advertiser*.

Violet Yap, the first director of the gallery, started many of the traditions that made the gallery successful. Her efforts turned the openings into community events. She made sure there was a reception line that included herself as director, Twigg-Smith, and the exhibiting artist. She also started the tradition of securing two sponsors for every exhibit. This practice created well-attended openings featuring a bountiful table usually provided by the family or friends of the exhibiting artist and an open bar sponsored by the *Advertiser*. It created an atmosphere of celebration and a bond among the artists. The gallery on opening night was inevitably filled with friends, family, and a community of artists who supported each other by their presence.

Jack Newton followed Violet in 1970. He was our first "professional" art administrator and created a format which included uniform invitations for the exhibitions, with the exhibiting artist in charge of installation.

In 1975, Laila Twigg-Smith became the director and renamed the gallery the Contemporary Arts Center. She took over the responsibility of exhibition design and, with her larger-than-life personality and vision, galvanized a team of volunteers to help

her each month in creating dramatic exhibitions. Under her leadership, the gallery ushered in a decade of remarkable growth and created new levels of art awareness in our community. Laila introduced theme shows, juried exhibitions, group shows of varying sizes, and other exhibits that turned into special events. The collection acquired works by many nationally known artists and continued to support Hawai'i's own. The Wednesday night openings ushered in a period of great camaraderie between artists, a time when anything seemed possible. The sense of community and joie de vivre ignited the air with a palpable energy. These were the years that unified our community of artists and changed the landscape of art in Hawai'i.

In the background was a team of dedicated artists, the unsung heroes of this effort. Linda Gué and Fae Yamaguchi were the cogs that turned the wheels. Many artists helped with exhibition installation and the myriad details that went into Laila's extravaganzas. Barbara Engle was a tireless volunteer during this period. Everyone contributed what he or she did best.

There were other venues for art, including the University of Hawai'i Art Gallery. Under the direction of Tom Klobe, the University continues to present inventive gallery exhibitions. The Honolulu Academy of Arts carries on a tradition of community awareness begun by its founder, Mrs. Charles Montague Cooke, who also built the central part of the house that is now the site of The Contemporary Museum. Indeed, the main house is named after her daughter, Alice Cooke Spalding, who remodeled and added to it extensively. The few commercial galleries that operated during the early years of the Advertiser exhibitions also contributed immense support for Hawai'i's artists: Charlene Teshima of Gallery EAS, Joan Gima and her sister, Susan, at Gima's, Greg Northrop at The Downtown Gallery, Lucille and Catherine Cooper's The Hand and Eye, and Daisy Kurashige of Daisy come to mind. A history of the period wouldn't be complete without including Alan Leitner and The Foundry. The Foundry was a gathering place for craftsmen to work, and the Leitners gave special support to all the artists who exhibited there. Alan still calls me at the office to have a morning cup of coffee, and we end up talking until noon. I think we all want to recapture some part of those years.

In 1983, Mary Mitsuda became director of the Contemporary. She continued the tradition of presenting the unexpected in unexpected ways. Her work with artists, including preview publications and *Have You Got a Minute?* in 1985, a show of 20 artists in 60-second performances, manifested the remarkable creative spirit of the time.

In 1988, The Contemporary Museum was created through Persis Corporation's gift of

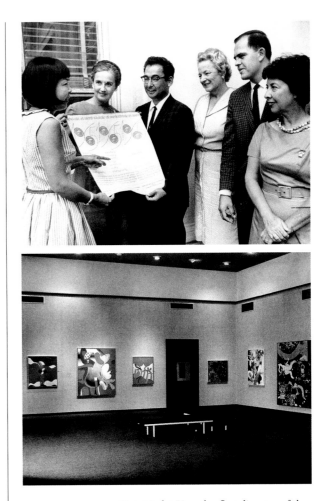

Top: Violet Yap, the first director of the Contemporary Arts Center, confers with, from left, fellow art supporters Virginia Rice, Stanley Yamamoto, Alice Kuhlmann, Thomas Schafer and Ivalee Brown in October 1964.
Bottom: With the courtyard enclosed, the Advertiser Gallery becomes a sleek interior gallery space. Shown here is Ken Bushnell's exhibition of paintings in June 1965.

15

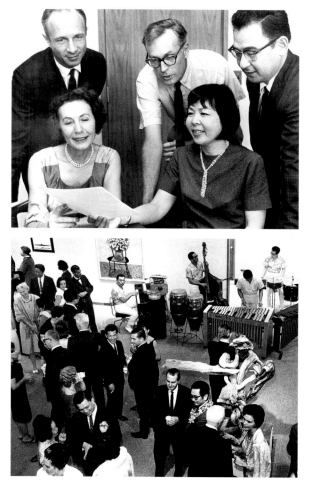

the Spalding home in Makiki Heights. Its donation of 1,200 works of art also seeded the permanent collection of the new museum. Persis Corporation and the Twigg-Smith family continue to encourage community participation in maintaining the museum and its gardens for the enjoyment of everyone.

The Contemporary took over the Advertiser Gallery to continue a museum presence in the News Building, but that ended with the last exhibit, *So Long Salon,* on March 30, 1998, the day the gallery closed its doors. Laila's death, seven days before the closing, evoked sadness and disbelief in Hawai'i's art community. The gathering of over 800 art lovers was a good-bye to her as well as the gallery.

Certainly the most important ingredient throughout this history was the artists themselves. The seventies and eighties were a period of unusual freedom for artists here and abroad, and Laila gave them opportunities and nudged them to produce results beyond their dreams. The exhibitions at the gallery brought out the best Hawai'i had to offer. It was an exciting time.

From the start, Jay [James] Jensen has been a strong, silent force in the acquisitions for Persis and the museum. In the context of art, he is the heart of The Contemporary Museum. Driven by pure passion, Jay has amassed a permanent collection for the museum that is startling in its depth.

To get a collective impression of this period, Jocelyn Fujii has spent months interviewing artists, past directors, and other people who played a role in the gallery. This book is a record of those recollections. Included between these covers are many of the photographs taken at the openings during those years, and many of the images that make up the collection. It is my sincere regret that everyone involved and every piece collected could not be included. However, I hope that this book, *The Persis Collection of Contemporary Art,* will serve as a memoir of a place and a time, a time that was special to Hawai'i's art and artists. I would like people to know that this happened in Hawai'i, and it can happen again.

Sharon Twigg-Smith

Don Eddy: AUTUMN LIGHT, *acrylic on canvas, 1986*

Masaaki Sato: NEWSSTAND #40, *oil on canvas*, 1987

William T. Wiley: UNTITLED (JAPAN), *colored pencils, acrylic, charcoal on canvas, with wood, string, found objects, 1982*

Paul Wonner: SUMMER, *acrylic on canvas,* 1987

Joel-Peter Witkin: Printemps, New Mexico 5/12, *toned gelatin-silver print, 1993*

Timothy Ojile: VENUS AND APOLLO, *liquid polymer, paint and crayon on paper*, 1995

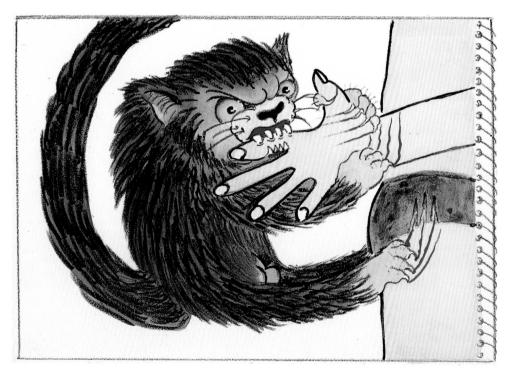

Kathy Everett: SCRATCHING PANTHER 3/20, *lithograph*, 1989

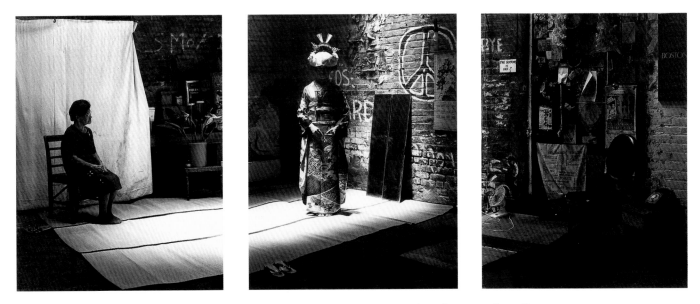

Shuzo Uemoto: AFTER THE BANQUET 3/5, *photograph*, 1981

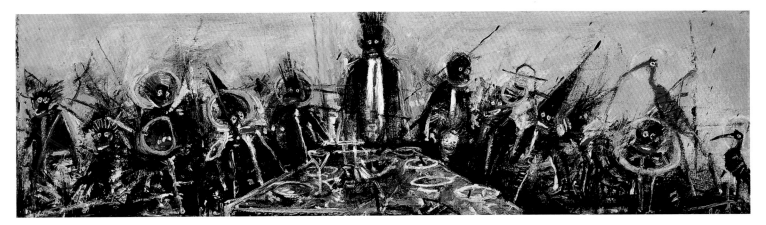

John Alexander: THE ARRIVAL OF AN UNWELCOME GUEST, *oil on canvas*, 1985

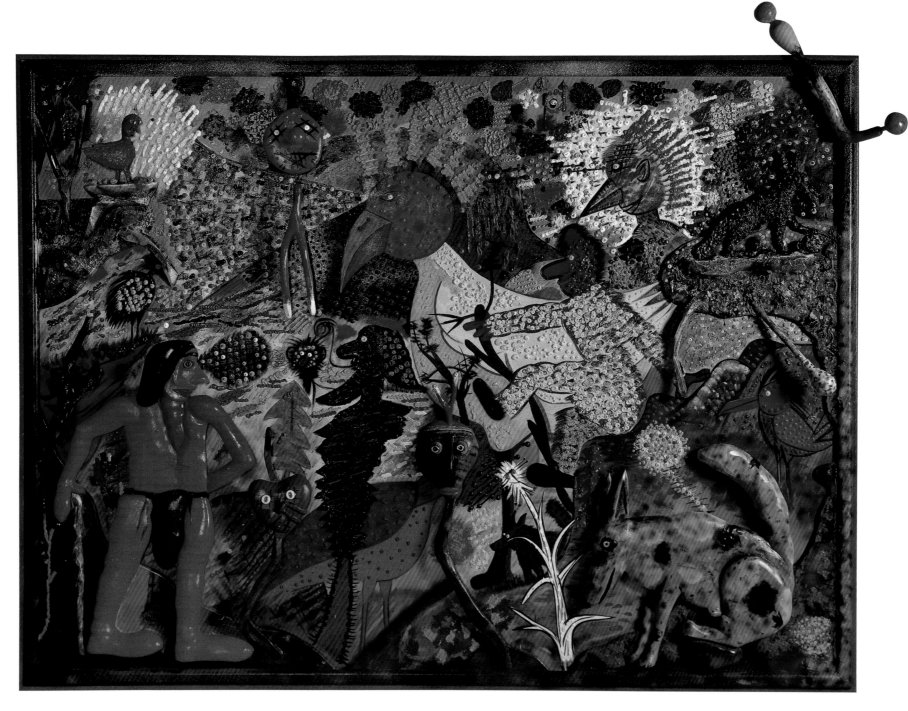

Roy De Forest: A VISION OF ARCADIA, *acrylic on canvas, wood, 1988-89*

A History

Jocelyn Fujii

It was a good year to declare new freedoms. A year of passionate crossings: 1961, when John F. Kennedy was inaugurated President of the United States and four Liverpool mop tops named the Beatles emerged as international icons. The birth control pill became available that year, and Henry Miller's *Tropic of Cancer* reappeared in this country following a 27-year ban for obscenity, launching permanent debate over rights of the body and rights of the mind and the new frontiers of liberation. Dancer Rudolf Nureyev defected from the Soviet Union that year as astronauts first hurtled through space. The repressed childhood of the Fifties was a memory, replaced by a fresh new decade that welcomed screw-on beer caps, a tribal culture, poets and political resistance. "Dare to struggle, dare to grin," exhorted the late Abbie Hoffman. The times were pregnant with promise, and Hawai'i, a two-year-old star on America's banner, toddled giddily forward, basking in the promise that commercial jet travel had introduced only two years earlier. This was a time of explosive, jubilant freedom, and art was its potent reflection.

In 1961, in the central courtyard of what is now the News Building in Honolulu, while the inky presses of *The Honolulu Advertiser* roared and hummed with its headlines, two island-born artists prepared a joint exhibition that launched a new era for the fiftieth state. Sculptor Bumpei Akaji and painter Tadashi Sato had much in common. Japanese Americans, both had served in the highly decorated 442nd Regimental Combat Team from Hawai'i in World War II; both had studied abroad—Akaji in Italy, Sato in New York—before returning to the Islands for what would become long and prodigious careers. Around the courtyard fountain, the exhibition featured Sato's paintings, Akaji's sculptures, a Chinese dragon dance, and New Orleans jazz by the Dixie Cats. Throngs milled around the courtyard, and a cadre of volunteers worked tirelessly under the guidance of Violet Yap, the first director of the gallery. Hawai'i's senior senator to the U.S. Congress, Hiram Fong, paid tribute to the artists in what was a rousing, multicultural beginning for The Honolulu Advertiser Gallery, home of the Contemporary Arts Center.

"It was the first of what eventually became monthly exhibitions there, and from the beginning, we had a policy of buying at least one piece from every show," recalls Thurston Twigg-Smith, chairman of the board of the Persis Corporation and former publisher of *The Honolulu Advertiser*, one of Hawai'i's two daily newspapers. "From the

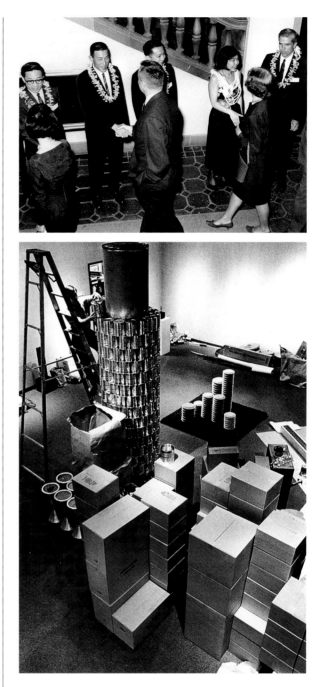

Top: Thurston Twigg-Smith, right, heads the receiving line at an opening at the Center in 1965. A gathering place for Hawai'i artists, the gallery was the first program of ongoing support for contemporary art in Hawai'i.
Bottom: The John Wisnosky exhibition in February 1967.

William T. Wiley: FAN FOR THE A.M., *acrylic/colored pencil on canvas, 1984*

start, there was tremendous community support. With major financial assistance from Clarence Ching, we enclosed the courtyard in chicken wire and called it a gallery. There were no blocks to moving ahead with this idea of providing exhibition space for local artists on a regular basis. It was unplowed territory, and it just took off."

Promotion manager of *The Honolulu Advertiser* at that time, Twigg-Smith established a gallery that gained prominence as one of the first exhibition spaces provided by a corporation for Hawai'i artists. By purchasing work from each exhibit for display throughout the News Building, the *Advertiser* created an environment of interaction and accessibility between art, artist, and work place. In 1977, two years after artist Laila Twigg-Smith was hired as its director, The Honolulu Advertiser Gallery became the Contemporary Arts Center, and in 1980 the exhibitions were expanded to include national artists. The collection that resulted, the Persis Collection of Contemporary Art, gained renown as one of this country's most notable. Its sheer size made it a community resource that seemed more properly a museum than a collection surrounding an exhibition gallery. And in 1981, the decision was made to move in that direction.

"Wednesday night openings at the News Building got to be the happening place for artists," recalls Sharon Twigg-Smith, curator of the Persis Collection since 1986. "Laila had a special talent with installations. She devised dramatic, consistently creative ways to show off the art. The shows changed every month, and on opening night, every artist in town could be found at the Advertiser. It was a place to greet friends, exchange information, and show support for the artist who was exhibiting. There was an energy, a synergy. There was something in the air, a spark, a magic. It was a special time for all of us."

A confluence of spontaneity, resources, and independence of spirit charted the course of this collection. As it grew, the Persis Collection gained a high profile in corporate and art circles. Hundreds of exhibitions after 1961, the Persis Collection continues to be defined by a high level of curatorship and spirited philanthropy, with a presence well known in the major art centers of the world. Its works go on loan from coast to coast, in vaunted institutions such as the Smithsonian, the Yale Art Gallery, the Whitney Museum, the Guggenheim, the San Francisco Museum of Modern Art, the Los Angeles Museum of Contemporary Art, and the Honolulu Academy of Arts. Its list of artists reads like a Who's Who in contemporary art, yet many are the luminaries of the future. Twin Farms, Persis Corporation's 14-suite, 300-acre country inn in Vermont, is as renowned for its art—200 pieces from the Persis Collection—as for the features that have won it a Mobil Oil Five-Diamond Award two years in a row and the number-one position in the national Zagat Survey. Whether viewed in Honolulu by an employee at the News Building, which in 1998

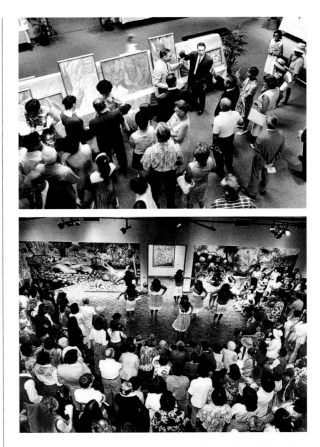

Top: In August 1966, a sale is held of Jean Charlot frescoes donated by what is now First Hawaiian Bank as it remodeled its Waikiki branch.
Bottom: The Martin Charlot opening in February 1979 attracts a large and diverse community of supporters.

27

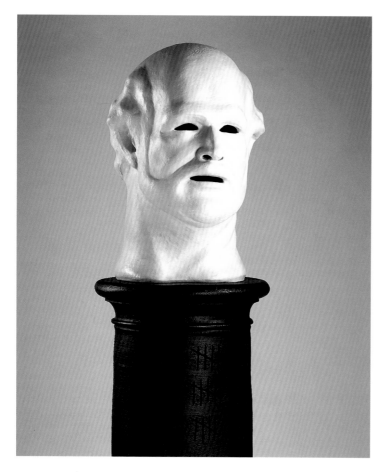

Robert Arneson: PORTRAIT AT 62 YEARS 1/3
bronze, 1992

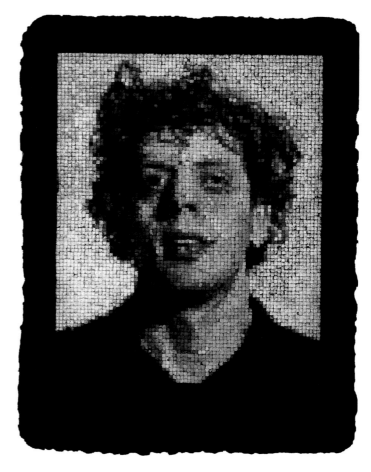

Chuck Close: PHIL III
pigment and handmade paper pulp, 1992

still housed much of the collection, or by a guest at Twin Farms, the Persis Collection is one of the most divergently accessible art collections in the country.

"Although national in scope, our collection has never deviated from its original goals," explains curator Sharon Twigg-Smith. "Our goals have always been to support the visual arts and Hawai'i artists, to create a greater awareness of art in the workplace and community, and to gift pieces to various museums, particularly our own Contemporary Museum. At the same time, we've consistently imported quality works from major mainland art centers." With its gallery, monthly exhibitions, awards to artists and art programs, and consistent acquisitions program, the Persis Collection was the first comprehensive program of support for contemporary art in Hawai'i, established four years before the State Foundation on Culture and the Arts and six years before a state law required that one percent of the cost of new state buildings be designated for art.

"The Contemporary Arts Center was a very important entity," reflects James Jensen, associate director and chief curator of The Contemporary Museum. "The 1970s were a lively period, and a lot of the arts activity at the time reflected the personality, point of view, and attitudes of the Twigg-Smiths. They were always interested in doing the unexpected, not necessarily going by the rules."

First Violet Yap (1961–1970), then John Lee Newton (1970–1975), Laila Twigg-Smith (1975–1983), and finally Mary Mitsuda (acting director 1983–1985, director 1985–1986), charted the course of the gallery and collection as successive directors of the Contemporary Arts Center, a process that resulted in its transition to museum status. In 1982, the Persis Collection donated 1,200 works to seed the permanent collection of The Contemporary Museum. In 1986, Fritz Frauchiger was hired as the first director of the yet-to-open TCM, to oversee the museum collection and the remodeling of its chosen site. Two years later, in 1988, The Contemporary Museum opened its doors in the grand, brilliantly renovated Alice Cooke Spalding estate on the slopes of Tantalus.

Persis has left an indelible mark on the cultural landscape of Hawai'i. By the early 1990s, its art acquisitions budget had expanded to more than $1 million a year. The News Building became an important resource for local artists and students, the only place in Hawai'i to see contemporary art on a national scale. "Artists are always affected by what is happening elsewhere," explains Sharon Twigg-Smith. "The geographic insularity of the Islands separated artists and made it difficult for them to see what was happening in contemporary art outside of Hawai'i. It's hard to keep up to date when you can't see what's new. The News Building provided that opportunity even more than the Honolulu Academy of Arts, which was the only other place that exhibited mainland work on any kind of regular basis."

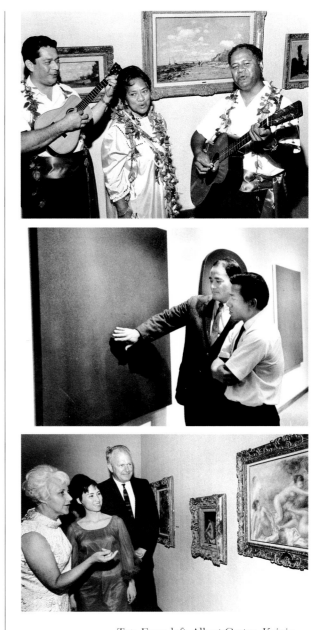

Top: From left, Albert Castro, Kaipio Kauhane, and Daniel Spencer provide the Hawaiian musical flavor at the William Twigg-Smith opening in January 1965.

Middle: Tadao Beppu and Hiram Kamaka peruse a work titled *Maybe Blue* at an opening in November 1967.

Bottom: Viewers admire a work in the Arthur Murray exhibition of French Impressionist paintings, February 1969.

Ken Kingrey, standing, works with assistants during an installation of Madge Tennent paintings in February 1968. Donald Angus, owner of many of the paintings, requested that Kingrey oversee the design and installation.

"For more than 35 years, it [Persis Collection] has been a catalyst in contemporary art in Hawai'i," observes James Jensen, who came to The Contemporary Museum in 1991 after 15 years with the Honolulu Academy of Arts. "I think it's responsible for building an audience for contemporary art, because it led to the creation of The Contemporary Museum. It was the vision of individuals, but it has generated remarkable community support and response. Certainly the Advertiser Gallery and the Persis Collection are great examples of what can happen in a corporate environment."

Within the corporate culture, Persis is remembered for the boldness and spontaneity—a distinctively unstuffy modus operandi—with which it went about collecting works in the generally stiff business world that was riding the wave of 1980s affluence. Due to Thurston Twigg-Smith's long-instituted policy of donating ten percent of the corporation's annual taxable income to various philanthropies, arts programs also received extraordinary support. In the last thirty years, Persis shareholders have given more than $30 million in gifts, most of it in culture and the arts.

While the significance and quality of a work were considered, the Persis Collection through the 1970s and '80s was notable for its personality, its carefree, unconventional nature. "They bought based on their reaction to the work, not necessarily where it was going to go," notes James Jensen. "It was not buying just to fill walls. In fact, it went beyond the walls to fill a warehouse."

"As a corporate collection, Persis really wasn't very corporate," recalls George Adams of the Adams Gallery at 41 West 57th Street, New York. "There are not many collectors these days willing to be idiosyncratic, to follow their own instincts." In fact, adds Adams, a well-known gallery owner, so iconoclastic is the Persis Collection that "I don't even see it as a corporate collection. It may be in an office building, but the way it was assembled was according to individual taste and direct response. I don't recall ever being asked to pull out a biography. Theirs was a very personal approach: 'Do we like this?' It was never self-important."

In 1986, when Sharon Twigg-Smith was hired as curator, the Persis Collection expanded its scope by increasing its acquisitions by mainland and international artists while continuing to support local artists. "In the late 1980s and early '90s, the collection took on a broader scope," explains Jensen. "Many of the mainland artists' works currently in the collection were acquired during that time period. The collection took on greater importance as a corporate collection as it brought in works by many artists who hadn't been seen in Hawai'i before."

In the late 1980s and early 1990s, pieces by Robert Stackhouse, Richard Prince,

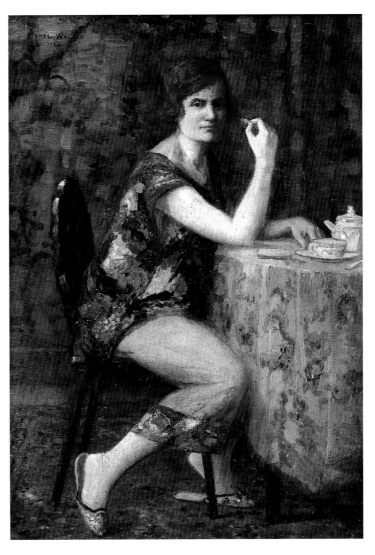

Duane Hanson: SECRETARY, *fiberglass, oil painted, 1972* Lionel Walden: SHIRLEY RUSSELL, *oil, 1925*

Top: Tilt: a Light Environment, a
collaboration between Ken Bushnell,
John Wisnosky, Harold Tovish and
Helen Gilbert, illuminates the gallery
in December 1969. *Tilt* is remembered
as the first environmental art show in
Hawai'i.

Bottom: A State Foundation on
Culture and the Arts opening
celebrates the tenth anniversary of
statehood at the center in August 1969.
From left, Alfred Preis, SFCA director;
Masaru Yokouchi, chairman; and
Lucille Cooper, SFCA board member.

Charles Garabedian, José Bedia, and Vernon Fisher were added to the collection. Works by other nationally known artists such as John Buck, William Wiley, Roy De Forest, James Surls, Robert Arneson, Jennifer Bartlett and Squeak Carnwath were collected in depth. In 1989, Sharon Twigg-Smith initiated an annual *Selections* exhibit in the gallery, under the aegis of The Contemporary Museum, that would highlight the year's corporate acquisitions. Fritz Frauchiger, the museum's new director, installed the first *Selections* exhibition, a tradition that Jensen continued. These exhibitions highlight the range and quality of the Persis Collection.

When she saw the collection in the early 1990s, says Sique Spence, director of the Nancy Hoffman Gallery at 429 West Broadway, New York, "I was amazed by its range and ambitiousness. I could see that the collection had come from many different resources. It was eclectic, broad-minded, spirited, stimulating. I was impressed with the way they integrated the collection in the high-pressure environment of a newspaper. I thought it was a wonderful way to share their resources—not only with the working environment, but with the general public."

In a time when the ease of public funding can no longer be relied upon, the Persis Collection makes a seminal statement about art in workplace and community. Its paintings, drawings, prints, photographs, ceramics, sculpture and textiles, spread out over three floors of a bustling news building, include works from the 1940s to the present, most of it from the 1980s and '90s. While many corporate collections are driven by concerns about status, image, or making an impression, the Persis Collection exists equally for those working in the building. In a state that is smaller, newer, and less urbane than most of its American counterparts, the collection represents exemplary private-sector support for the arts.

In the late 1990s, when "de-accessioning" is a function of downsizing and art auctions are the grim reaper for many corporate collections, Persis still runs counter to convention. On the future of the collection, Thurston Twigg-Smith points to institutions. "I don't like selling the art," he says. "I like putting it into the public domain, and our shareholders have thus far agreed." Private education and culture and the arts, two areas of particular interest to Persis, are targeted for eventual distribution of parts of the collection.

"All things were possible in the '70s and '80s and now that's not so," observes James Jensen. "For everyone, life has become exponentially more complicated and busy. The contemporary art world has become much more businesslike. That is one thing that differs from the early days of the Contemporary Arts Center, when things were informal and shared by the community. Everything is more professional now—hopefully a good thing—but there may be more restrictions. Some things are gained, but some things are lost, too."

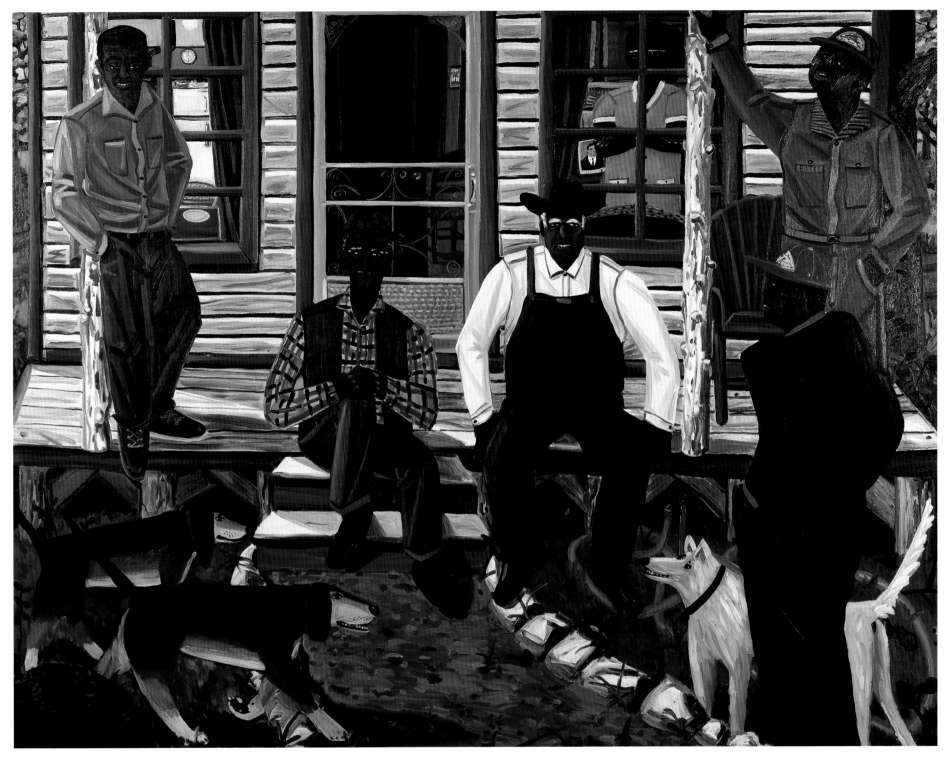

David Bates: ED'S HOUSE, *oil on canvas*, 1984

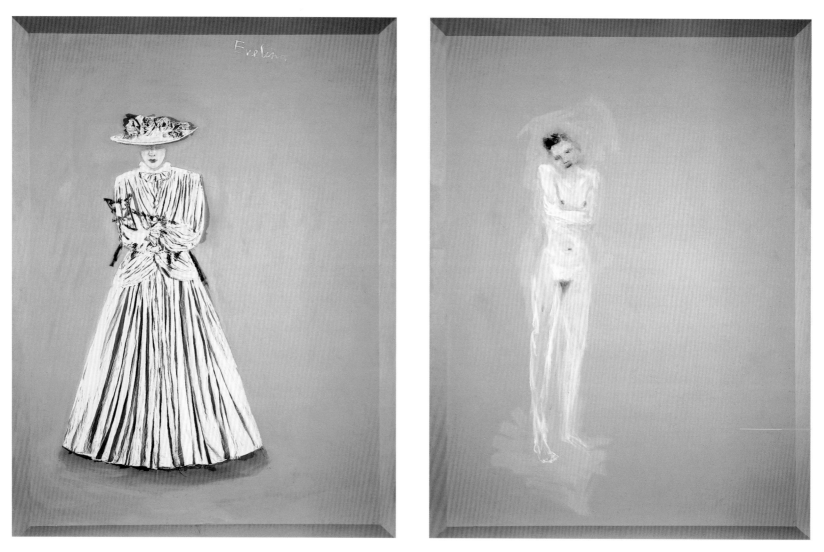

Nicholas Africano: Evelina, *acrylic, oil, gesso, cast cloth, canvas, 1984-85*

Howard Farrant: LONE WOLF, *lithograph, 1989*

Helen Sroat: ANTITHETICAL BALANCE, *acrylic, 1987*

Patricia Tobacco Forrester: THE POND BEYOND, *watercolor, 1984*

Denise DeVone: NIGHT PHASES, *mixed media, 1982*

Nic Nicosia: NEAR MODERN DISASTER #8, *cibachrome print, 1983*

Charles Valoroso: HAWAII... LAND OF ALOHA
acrylic on canvas, 1989

Nina Hagiwara:
TANK TOP *(left)*, T-SHIRT *(right)*, *clay, 1981*

Yvonne Cheng: NIGHT RIDE, *paper collage/watercolor, 1991*

Fae Yamaguchi: THE PLANET, *papier maché*, 1985

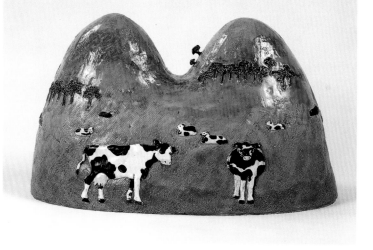

Kay Mura: WAIMEA PUʻU WITH COWS, *clay*, 1975

Hanae Uechi Mills
CLIQUE OF TRENDY INTELLECTUALS, *ceramic*, 1985

Hank Murta Adams: HOVERING, *glass*, *metal*, 1984

Reflections

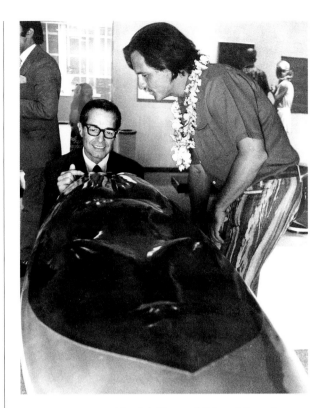

THURSTON TWIGG-SMITH (*CEO, Persis Corporation*): It began in late 1960, when Dick Habein and David Asherman, a Hawaiʻi artist, were having lunch next door [to the News Building] at the Columbia Inn, then called the Times Grill. It was before I became publisher. I was head of the newspaper's promotion department at the time. The two suggested that we create a gallery in the middle of the building. At that time there was a fountain in a garden court, open to the sky and the surrounding work areas, quite noisy but largely unused. I thought it was a great idea and gave it the go-ahead. Violet Yap, the first director, got volunteers from all over the island to come in and work. Clarence Ching became heavily involved. He put up enough money to buy the materials—the lumber and the chicken wire—and we got a contractor on a volunteer basis to put up the wire all around the gallery.

LAILA TWIGG-SMITH (*former director, Contemporary Arts Center*): In the beginning, they were all local artists' shows. Violet Yap got every ethnic community to come and bring pupus [snacks]. With virtually no budget, they depended on contributions.

MINNIE FUJITA AND HARUE MCVAY EXHIBITION NOTES (*March 1965*): Mr. and Mrs. A.G.M. Robinson, donation of the wiliwili branches for the flower arrangement by Ms. Kiyoshi Kamemoto; Coca-Cola Bottling Co. of Honolulu, donation of 500 paper cups; Mitsuwa Kamaboko Factory, donation for fish cakes; Mr. Shinzaburo Sumida, donation of sake.

SHARON TWIGG-SMITH (*artist and curator, Persis Collection*): At that time, the exhibits went up and came down every month, a monumental task. Everyone looked forward to them. Often they were controversial, and sometimes we had disgruntled employees passing petitions to have the art removed. But people remembered these exhibits long after the installations came down. There was a sense of community. Artists had something to look forward to, a regular venue, a place to exhibit. We artists lived and breathed art, and we saw each other every day.

Frank Milici and Edward Stasack at a November 1970 opening, featuring works by the faculty of the University of Hawaiʻi art department.

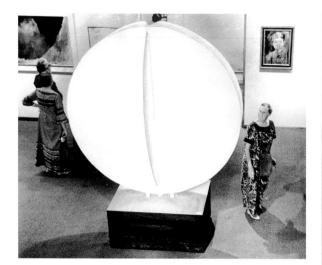

Top: Mamoru Sato's *Sculpture '71* (also titled *Sol V*) is a compelling piece in the February 1971 show at the Contemporary Arts Center highlighting the center's permanent collection.

ALAN LEITNER (*artist, professor, Leeward Community College*): The town was pregnant, ripe for something to happen, and everyone around at that time got to take part. There were nights when every gallery in town had an opening—The Downtown Gallery, the Advertiser Gallery, The Hand and Eye, Daisy. Starting at the Advertiser and moving across town, we'd go to every opening in one night. The artists had nice working relationships with each other. We weren't competing, we were supporting each other.

ALLYN BROMLEY (*artist and professor, University of Hawai'i*): We formed a women's group that began showing together, twelve artists in different disciplines. We stayed together until the early nineties. In the beginning, we were young and full of inspiration and commitment and questions, and we were searching, probing for all kinds of answers and feedback. We were very supportive in helping each other as artists.

THURSTON TWIGG-SMITH: Those early openings at the Advertiser became the gathering place, and you could expect 300 at an opening. The viewers were eager. It was new and exciting. There weren't other places like it—the open bar, the great pupus, were trademarks that helped bring people.

DOUG YOUNG (*artist*): My first show for the gallery was in 1973. When I returned from college, I had a body of work that I thought was really good. I ran around town and couldn't get any shows. At that time there was the Foundry and Gallery EAS, and I'd knock on their doors: "Can I get a show?" The only person who was interested was Jack Newton at the Advertiser Gallery. He gave me a show. There was one wall that was empty because I didn't have enough pieces. He said to me, "Why don't you do some small watercolors?" That's how I started painting watercolors. I started doing images of old mom-and-pop stores, old places around town, and they were $175. I thought, wow, that's a lot of money, and these guys are buying them, this is great! They all sold, about six or seven of them.

LAILA TWIGG-SMITH: When Jack Newton left, I applied for the job as gallery director. I was offered $500 a month. I soon realized there was no office, there were no files, there were two boxes that Jack had filed things into, there was nothing. For a time I used a little round table in one of the executive offices, the closest thing I had to an office. When the telephone operators for the building moved, I inherited the closet that the phones were in. Finally, I had a real office. I started looking for an assistant, then office equipment, and it grew from there. Our beginnings were extremely modest.

SHARON TWIGG-SMITH: The "office" was literally a closet.

ROY VENTERS (*artist*): Having that little office was the seed pod that grew into the museum.

MARY MITSUDA (*artist, former director, Contemporary Arts Center and now stamp curator for Persis*): In the beginning, all Laila had to work with was this big gallery space and two movable, box-like exhibit walls that doubled as storage space. She was known for her exhibit installations, being able to present paintings and objects in a fresh way. We had a new show every month. At first she did it with whatever help she could muster, then it grew from there.

ROY VENTERS: We were at the beginning of things. Everyone worked hard. I remember that the very first monetary donations that came in were under the heading "Lovers of the Arts Center."

LAILA TWIGG-SMITH: When I got to the Advertiser Gallery in 1975, there were about 500 pieces in the collection. When Twigg and I got married in 1983, we thought we would just collect local art for the Advertiser Gallery and art from outside for ourselves. Eventually we were able to discern what would be great for our collection and for the corporation. There was rarely any conflict over which piece went where. The Advertiser Collection kept growing and growing, and we finally realized that what we really needed was a museum. The Contemporary Museum was like a star we were aiming at.

SHARON TWIGG-SMITH: Twigg and Laila went to Europe in the mid 80s, and one night I received a call from Europe. "Guess what?" Laila exclaimed. "We know what The Contemporary Museum will look like. Come see." We joined them in Copenhagen to see the Louisiana, which turned out to be the model for The Contemporary Museum. We were thrilled, because the Makiki Heights site was perfect for this concept. We were flying. We had the grounds, we had the house, we could fill it with art and do something totally unprecedented. We were brimming with confidence that it was going to be great. Laila's enthusiasm was infectious: It fueled the endeavor and took on a life of its own, so everyone involved got caught up in the excitement. Chris Smith remodeled the interior of the Alice Cooke Spalding house into a monumental museum experience. Janet Larson was brought in to run the museum shop. Loraine Pang, the fundraiser, the engine that made it all work, suggested that we would need a docent program. I brought in Kathleen Roeder to run it and designed a program using experts in every field we

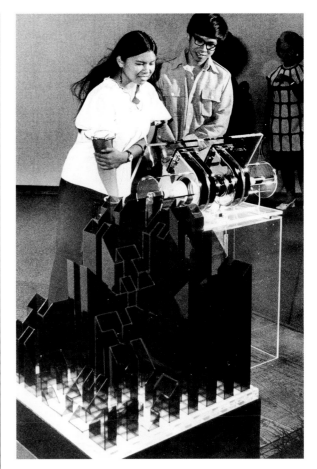

Two art lovers feel the breeze from one of Leighton Liu's "aerosculptures," featured in a May 1971 exhibition of works by Liu and Hobby Norton, whose work is shown in the foreground. Their constructions, which included kinetic sculpture, were based on mathematical principles.

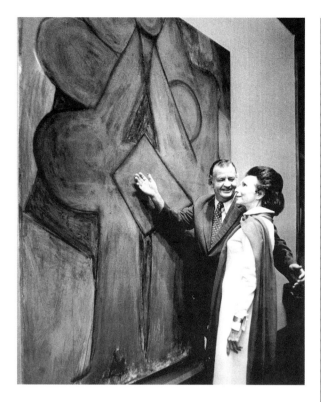

Ike Sutton and Charlotte Cades
examine *Red Form III*, one of five large
canvases shown by Joseph Goto in
January 1973.

explored. Louise Lanzilotti took over from Kathleen and continues to educate a dedicated corps of docents. An army of volunteers was recruited to plan the grand opening, including Allyn Bromley, who was the only artist doing screen-printing at the time. She designed the invitation for the grand opening of The Contemporary Museum, where she serves as a trustee and remains an invaluable volunteer. Meanwhile, the physical, the structural, development of the museum presented its own challenges.

CHRIS SMITH (*architect, designer of The Contemporary Museum*): We had to ask ourselves, what is a museum? How do museums work? An architect can design the outside like a piece of art, but the interior must pay homage to the work itself. If you look at different museums, you can see that some architects have taken the opportunity to build a monument to themselves. The one we flew over to see, the Louisiana, was a wonderful old mansion with wings that stretched out from each end in a sort of 'U'. It is always a struggle between art and its housing. You have to ask yourself, what do I do to maintain a respect for the art? For this museum, architecture was not going to be the dominant issue. It was to be housing for the art.

SHARON TWIGG-SMITH: Laila and Twigg started going to Los Angeles, New York, Chicago, to galleries all over the country and exhibitions in Europe. In the mid-80s they went to the Chicago Art Fair and came back with 68 pieces. I said to them, "What are you? Crazy?" They were. Early on, they were crazy.

LAILA TWIGG-SMITH: We were both collectors to begin with, so we went totally overboard.

GEORGE ADAMS (*owner, Adams Gallery*): They focused first on California but pretty much followed their own instincts. Roy De Forest, Robert Arneson, William Wiley, Joan Brown, H. C. Westermann, James Surls, Jose Bedia, and Jack Beal were among the artists whose work they collected. It seemed that the bottom line was whether the work moved them in some way, whether it elicited a visceral response. That's why they could respond immediately to artists they'd never seen before. In each case, there was a genuine sensitivity to what the artist was doing.

LAILA TWIGG-SMITH: At first the collection was never really the focus, it was a byproduct. It was all about the exhibition, about getting artists seen, getting their work known. We didn't have to sell to stay alive, so we could show art works that just warranted showing because they were good. It was a passion.

VIOLET YAP (*first director, Contemporary Arts Center*): The openings always started at 7 p.m. Mr. Twigg-Smith, the artist, and myself would stand in the receiving line, and it would go on all evening. There was always someone to receive you. You don't just walk in blank, you know. Each show was sponsored by *The Honolulu Advertiser* and a sponsoring group, which could have been a relative, friend, or community organization. They would take charge of pupus, and they enjoyed it.

DOUG YOUNG: The people at my first show were, of course, kind of sparse, but my family was there, and the later shows drew more people. I guess as you become more known, or people know that there's good food, word gets around: "Eh, Doug is having his show. Must be good food there!" People brought plants, food, gifts, orchids. Some people would make sushi, or stir fry, and of course, fried chicken. Gary Nomura one time made me a lei of dried fish, the really small fish. He strung it himself. I had that fish lei for awhile. Did it smell? Yeah. Ruth Tamura did all these strange things. She was famous for her off-the-wall leis. One time she wrapped ceramic fish in cellophane and made a lei. Or she'd make a lei out of fishing lures, the colorful jiggly ones with the glitter in them. In Hawai'i, if you go to young emerging artists' openings, you'll always find family. Families usually make food for these openings. Those openings were like high school graduations—leis to the top of your head. In my generation, we didn't have to go through the hardships of our parents and grandparents. People in my generation are able to go into the arts and dance and writing because they don't have to worry that much about just getting food in their mouths. Their parents are supporting them. To survive, at that time, I was able to get my clothes washed, instead of usually handwashing them in the bathtub. I would, on occasion, take them to my mom's house and get a meal at the same time. They don't go and slap you on the back or encourage you, they don't say anything about it, but Oriental style, they supported you. That support is integral.

ROY VENTERS: As an artist, you get so hung up on surviving that you stop doing what you need to do creatively. At the same time, when I look at my life and look at my art and look at my struggles, art is what gives me the will to live.

FAE YAMAGUCHI (*artist and former collections supervisor, Contemporary Arts Center*): I'm trying real hard to sell out.

SHARON TWIGG-SMITH: In 1975, I saw Roy Venters' show at the Advertiser Gallery. He brought in trash and things he'd collected from all over, and he started hanging it

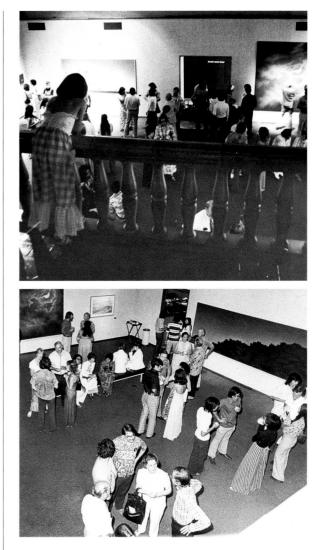

Top and bottom: The paintings and drawings of Don Dugal draw viewers to the gallery in April 1974.

John Kjargaard: Sunset Landscape, *oil on canvas, 1976*

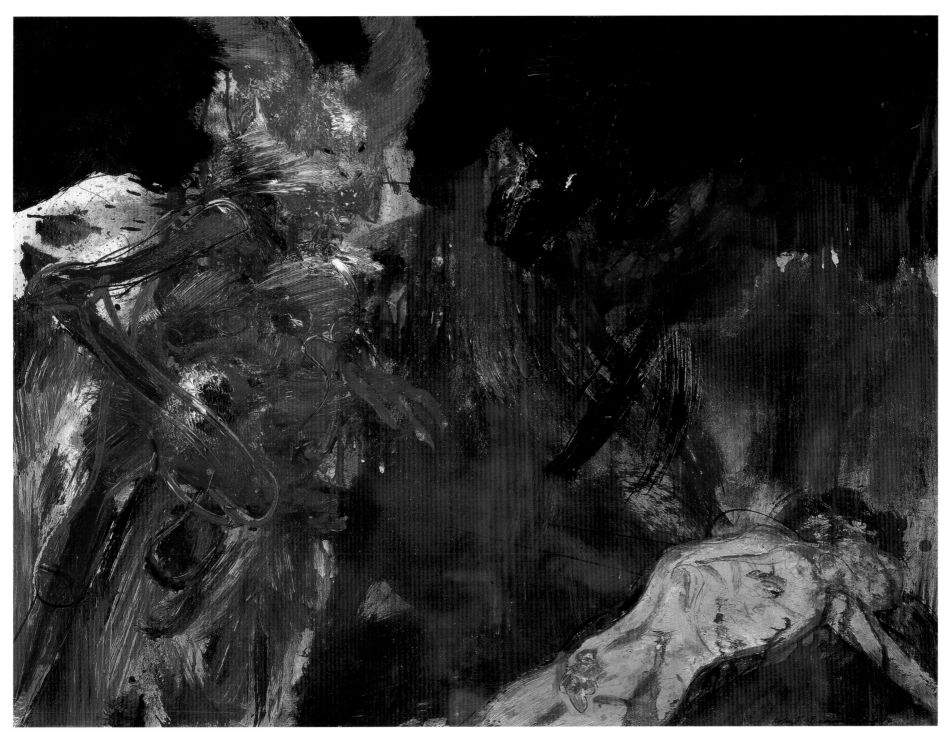

Robert Beauchamp: RED DEVIL THREATENING MALE NUDE, *oil on paper, 1986*

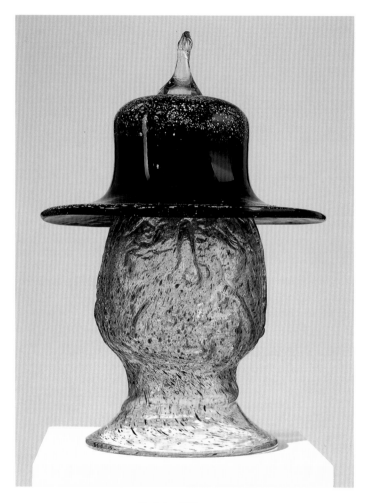

Robin Winters:
VAL ST. LAMBERT SERIES #79 - TESTA CORONATA
hand blown lead crystal, 1990

Tom Otterness: UNTITLED, *bronze, 1989-90*

Edward Ruscha: THINGS ORIENTAL, *oil on canvas*, 1985

Jerry Okimoto: PENCIL NO.4, *acrylic on shaped canvas*, 1972

Frank Stella: LA PENNA DI HU 8/42
etching, relief, aquatint, 1988

Cheryl Laemmle: TARGETS
oil on canvas, 1992

Tony Berlant: SNOOKS, *found metal collage on wood, 1986*

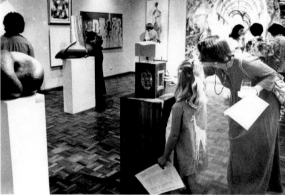

Top: Jerry Marquis contemplates *Homesick* at a one-man exhibition of paintings by Filippo Marignoli, October 1972, at the Contemporary Arts Center. *Bottom:* Viewers ponder the work of 64 male artists who expressed their concepts of women for *Men Look at Women,* an invitational group show in December 1977.

from the ceiling and all over the walls. He draped it through the air and I thought it looked like a drawing in space. Shortly before Roy's exhibit opened, my husband and I walked into the gallery and Roy ran toward us in his jeans and cowboy boots. He dropped to his knees on the slick parquet floor, slid right up to my husband, hugged him around the knees and said, "Please, please, please, Chris, buy me a new pair of cowboy boots for my opening!" Chris was speechless for a moment, then turned to me and said, "Is he kidding?"

ROY VENTERS: Oh my god, was I a one-trick pony?

SHARON TWIGG-SMITH: In Roy's show, the medium consisted of everything—string, rubber, cotton, popcorn out of boxes. The medium was detritus. The employees described it as garbage. I thought it was his finest hour.

ROY VENTERS: I lived in the gallery, literally, for three weeks while I was preparing that show. A lot of the materials were coming from the Swap Meet and from the dumpsters around Kakaako.

> HONOLULU STAR-BULLETIN *(Dave Donnelly column, July 11, 1975):* If you check out the exhibit by Roy Venters in the Contemporary Arts Center of the News Building, you'll find a new challenge for what you'll accept or reject as art. Our feeling about the collection was exemplified by the fellow who walked through the exhibit room a few days ago as Venters was installing the weird conglomeration of wire, paper, plastic and other 'found' materials. His comment to Venters: "You better get this junk outta here; there's an art show opening in a couple of days."

> CONTEMPORARY ARTS CENTER BROCHURE *(based on an interview with artist Roy Venters by James Jensen, Feb. 29 to April 11, 1984):* The works in this exhibition are variously made from astroturf, wetsuit rubber, placemats, Halloween costumes, installation rubber, erasers, sound insulation, hospital mattress rubber, carpet padding, expanding spray foam and many other things. This he jovially attributes to having read somewhere the phrase "a romance with rubber." These materials offer tactile qualities to which he responds creatively: "I can make rubber go into pretty much any shape or direction because it is so malleable. It's easy to cut. I can drill into it. I can poke things into it."

ALLYN BROMLEY: I had one show in 1976 at the Contemporary Arts Center. But my work at that time was on the wrong track. It took a tremendously wrong turn. It was bizarre, interesting, but as far as an art 'itinerary', it was a wrong turn. It was all acrylic plastic, dealing with light, real and illusory space. I took a lot of tsuji (nylon fishing line) and made a lot of tangles.

ROY VENTERS: I thought Allyn's show was right on track.

LAILA TWIGG-SMITH: Allyn Bromley's show was one of my favorites.

DON DUGAL (*artist, University of Hawai'i lecturer*): Her pieces were basically colored
drawings, screen-printed or sprayed on plexiglass sheets. A few of these constructions
were 3-D sculptures and were stitched or set with colored nylon filament. Was this the
show with the bald head, or the meatloaf covered with hair? I think the piece at Amfac
Center with the Women's Group was the bald head, so this one was the meatloaf. It was
an erotic and disturbing thing. It resembled a large meatloaf, but beautifully painted so it
looked like human flesh. And it was all set with hair, gray, sort of like that found at the
nape of the neck of an older man. It had wonderfully unfortunate overtones of being a
sex organ, a human head, a dinner piece, whatever. People were both delighted and
horrified by this thing.

MARCIA MORSE (*artist; from her show* Ritual Cloth: Paperworks, *Contemporary Arts
Center, October 4—27, 1978*): This series developed from earlier knotted paper pieces
which utilized a canvas mesh grid to give structure and support. The more recent pieces
use the canvas mesh laminated between two layers of handmade paper, with the paper
elements tied to/through this triple layer with thread. New concerns include use of the
bare mesh grid, perforation of the grid, and lacing with thread into the grid without the
addition of paper. The interplay of paper, color, and texture is also of primary concern,
and a palette for each piece is developed before construction begins.

ROY VENTERS: I'd like to make Marcia Morse live in a dirty house for a whole month.

THE LATE PHIL GIALANELLA (*former executive vice president, Hawai'i Newspaper
Agency, and former publisher,* the Honolulu Star-Bulletin *and* The Honolulu Advertiser,
in a letter to Laila about the Don Dugal exhibit, January 7, 1980): Laila: Why do you
make it so difficult for us in the Agency to love you? People are knocking into one
another with your most recent display. Help.

DON DUGAL (*in exhibition records, January 1980*): Of course I want my drawings to be
more than clever designs. I would like to think of them as large symphonic creations that

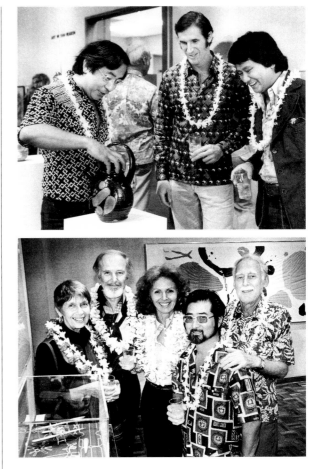

Top: Victor Kobayashi, Fred Roster and
Stan Hayase admire a teapot at a
December 1975 exhibition, *Art Within
Reason*, a 60-person group show. For
$150 or less, art lovers could purchase
works by Satoru Abe, Douglas Char,
Jean Charlot, May Chee, Lisa Chock,
Juliette May Fraser, Pegge Hopper, Kay
Mura, Ben Norris, John Wisnosky and
others.
Bottom: From left, Barbara Engle, Lee
Chesney, Allyn Bromley, James Koga
and John Kjargaard at *Invitational
Printmakers III*, an exhibition opening
in April 1978.

Margaret Ezekiel: BETWEEN THE SHADOWS, *pastel on dark blue paper, 1993*

Franco Salmoiraghi: SHIZUE LEE'S QUIET DANCE, *photograph, 1989*

excite, inspire, and transcend the labor that went into their creation… It's been brought to my attention how impractical these works are, and all I can answer is that's the way they have to be.

DON DUGAL (*discussing his 1980 show* To View Two Views): Over all the entrances, to control the lighting, I put up the equivalent of freezer curtains, made of tan Pellon. I wanted the room dark with the exception of the two 10x10-foot ink drawings. The drawings had a lot of detail to them, and I wanted viewers to become conscious of their movements as they advanced and receded to take in the 'whole' view of the work. I wanted something big and chunky on the floor that would make a sound when you walked around, like leaves. I had always admired this one tree in Moanalua Gardens. It had large leaves, and I had to go out there surreptitiously and pick enough nice clean ones to fill a box. I found out later that they were the leaves of the bo tree. Anyway, it didn't go down very well with the gallery staff, because the curtain and the leaves—well, you can imagine. The employees petitioned that the leaves were a health hazard, and it would be dangerous if someone slipped on one, so they had to be removed after the first day or so.

SHARON TWIGG-SMITH: Mary Mitsuda came up with the idea for *Have You Got a Minute?* It was a terrific presentation of art and artists, a masterpiece of staging, organization, and timing. It was the most impressive display of creativity I've ever seen in one evening. It took someone with a wacko brain like Mary to pull it off.

FAE YAMAGUCHI: There were twenty invited artists, and each artist had one minute in whatever medium they chose. It was performance art—dance, voice, poem, whatever. Don Dugal had a way with leaves. When Don came up, all these basil leaves were crushed at once, so there was this overwhelming basil fragrance in the room. I think his segment was called "Pesto Sapiens."

DON DUGAL: I love pesto. And not many people know that you need a mortar and pestle to do it correctly, because the leaves have to be crushed, not chopped. It was hard to get people to follow directions. There were baskets of tiny envelopes which were passed around to people, maybe a hundred fifty, two hundred. In the envelope were two basil leaves and a packaged towelette to wipe the fingers with. I chose not to appear in the skit but prepared projected instructions which told the audience to open the glassine envelope, take out the contents—I didn't say what the contents were—and

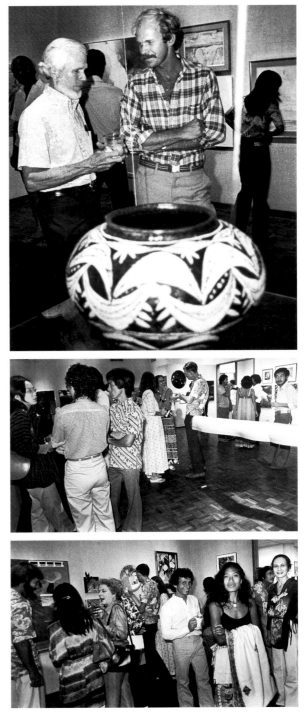

Top: Thurston Twigg-Smith and a fellow art lover at the opening of *In House,* featuring 65 artists, in June 1979. *Middle and bottom:* Carol Hasegawa, Marie and Paul Kodama, and others attend *In House.*

57

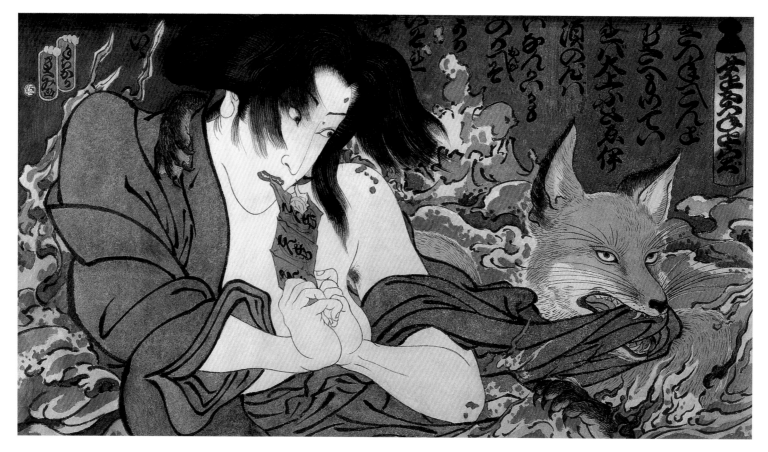

Masami Teraoka: AIDS SERIES/GEISHA AND FOX, *watercolor on paper*, 1988

rub them vigorously between index fingers and thumbs. Then inhale. Then open the moist towelette and wipe fingers. There was something like a collective sigh when everyone inhaled.

DENISE DEVONE (*artist*): Fae Yamaguchi dressed up as the Universe. She was a black blob on a cart, and she'd pick up the different planets and twirl them while a voice talked about the universe. She had Velcro on her costume so she could stick the planets on, but they kept falling off. It was hysterical. I did an animated film, "You Are What You Become." A couple drawn in black and white continuously danced in the foreground while behind them, in color, the process of evolution went on. The characters evolved from one-celled creatures to dinosaurs and cavemen, and ended with a rocket blasting off.

DON DUGAL: There were a number of ground-breaking shows. Helen Gilbert's *Tilt* in 1969 was the first real environmental art exhibit in Hawai'i that attempted to operate on the scale of mainland installation art.

HELEN GILBERT (*artist*): *Tilt* was a collaboration between Ken Bushnell, John Wisnosky, Harold Tovish, and myself. It was a light environment consisting of large prism-shaped structures in which colored fluorescent lights were mounted, behind and in front of polyethylene film. These were held in oppositional tension by stainless steel cables that traversed the gallery from side to side, above people's heads, tightened by turnbuckles. Sheets of silver aluminum lined the walls, and the entire floor was covered with plastic sheeting. The entire gallery looked reflective, like stepping into a painting by Turner or being in Venice on a rainy day.

SHARON TWIGG-SMITH: It was the first time someone had done an environmental installation. Being inside the art was a totally new experience for most people. It had a very Sixties quality—lights, LSD, a lot of those elements were in this piece, yet the experience itself was very new. People weren't used to experiencing art in this way.

HELEN GILBERT: In 1968, I was curator and one of the participants in *Light Incident*. One of my pieces was a snail-like structure which people walked into. Eight-foot white fluorescent light bulbs were mounted vertically against a curved, white, seamless wall. A computerized program turned the lights on and off in various rhythmic sequences. Karl Chang, a specialist in electronics, gave me technical assistance with the electronic program. The piece had a psychedelic aspect to it. When the lights pulsed at the end of

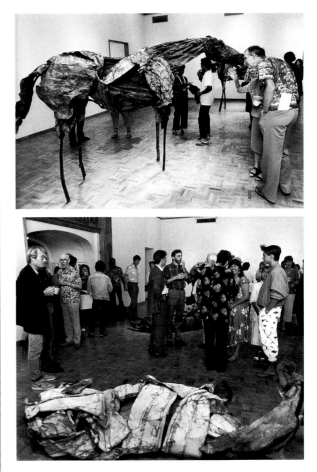

The Deborah Butterfield opening in March 1986 features her sculptures of elemental horses made of sticks, earth, and twisted metal.

59

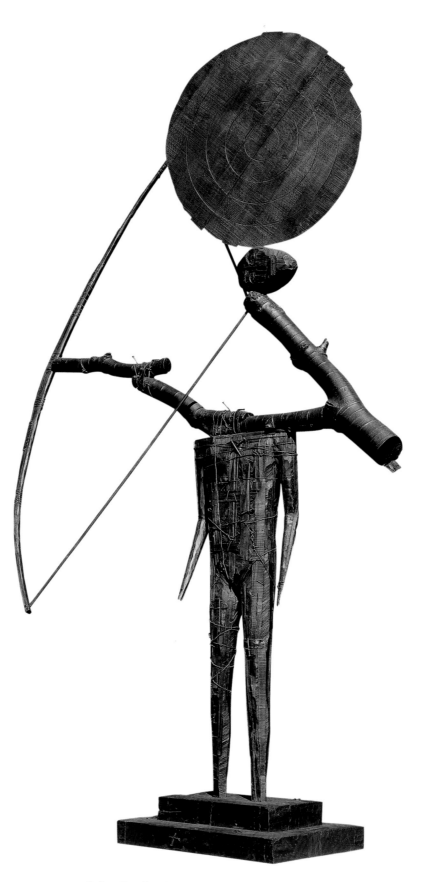

John Buck: THE ARCHER, *bronze, 1990*

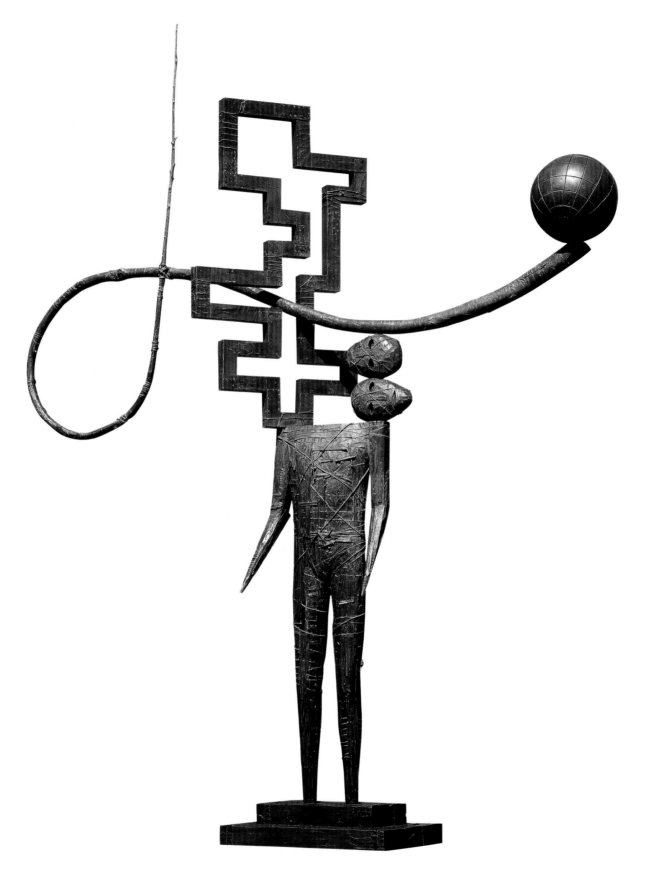

John Buck: Smokestack Lightnin', *bronze, 1991*

Alan Leitner: UNTITLED #2, *acrylic and oil stick on paper, 1992*

James Doolin: Oasis, *oil on canvas*, 1985-86

Marie Kodama: JOURNEY II, *mixed (ceramic/wire), 1984*

Esther Shimazu: CHECKED HANDKERCHIEF, *stoneware, 1993*

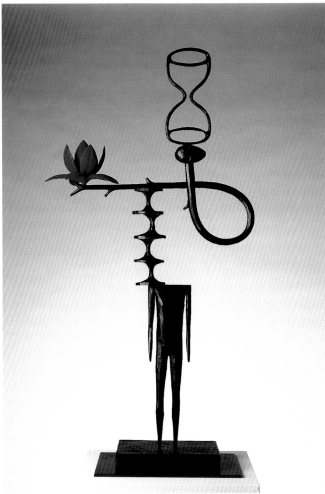

John Buck: SERIES FROM HOLUALOA #7
bronze, 1993

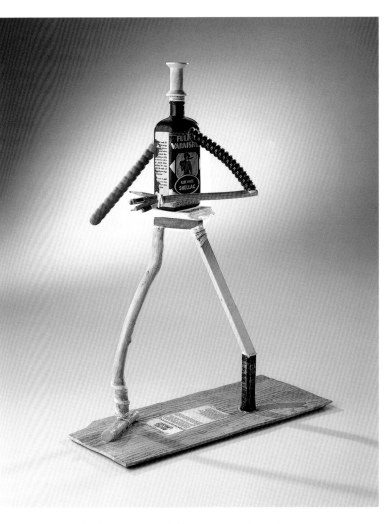

Richard Shaw: MAN WITH RED ARM
porcelain with decal overglaze, 1983-84

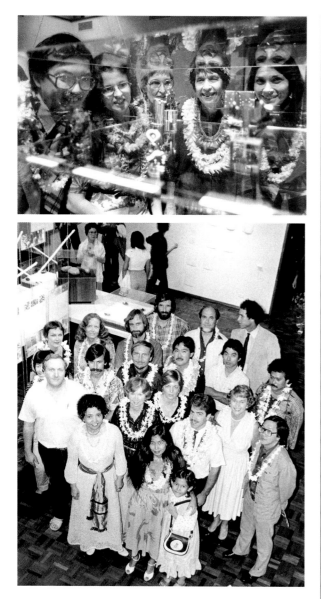

Top: Ronald Ai, Carole Bowen, Frances Pickens, Barbara Engle and Judith Beaver are photographed through an exhibit case at the November 1980 opening of the group show titled *Metals.*
Bottom: Artists and writers in the exhibition *Collaboration/Artists and Writers* gather in the gallery at the show's opening in April 1981.

each 10-minute cycle, viewers would perceive points of bright spectrum color similar to those in a pointillist painting by Seurat. On occasion, I'd come by to check the lights and find people lounging on the floor, some in business suits, 'experiencing' the piece.

MARY MITSUDA (*from a Contemporary Arts Center press release, November 19, 1984*): In all of Kadonaga's work there is a quiet, lyric quality. What was solid and closed becomes infused with light and air, what seemed inanimate is seen to breathe and move; a natural order is revealed through a precise man-made order, the invisible world is made visible. What makes Kadonaga's pieces 'sculpture'? Kadonaga's aim is to reveal the nature of the wood he uses. To do this he combines traditional and very modern techniques to create an apparent contradiction: a log which looks like a log and is also very dramatically altered.

LINDA GUÉ (*artist, former exhibits coordinator, Contemporary Arts Center*): Kazuo Kadonaga, the artist, was from a village in Japan where his family was in the lumber business. He had access to a machine that would shear lumber into thin sheets. A 12-foot log could be sliced paper-thin along its length, then reassembled to appear whole. It was exquisite. What first appeared to be a static log revealed subtle undulations in the thin layers as the wood reacted to the changes in the humidity.

FAE YAMAGUCHI: Twelve of his log sculptures were in the exhibit. He shipped them in beautiful crates. We had to build a ramp up the front steps of the News Building just to roll them in from the shipping container. Installing shows was often a nightmare.

DEWAIN VALENTINE (*artist, in a letter to the Contemporary Arts Center, October 19, 1984*): I will install "Open Diamond Rotated Hyperbolic Parabola," 8' h x 16' w by 8' d. I will be prefabricating the work from glass that comes from Italy. I will need the Contemporary Arts Center to pay both ways of shipping and packing. You will be exhibiting an exceptional work.

FAE YAMAGUCHI: For the Valentine show, we were expecting 8-foot strips of cobalt blue glass. But instead of sending the strips, he had glued them to form thirty-two 8x8-foot squares. The squares would not fit through the service door, so we had to bring them in the front door. It took four of us to lift one. We had to carry each one through the parking lot onto the sidewalk on Kapiolani Boulevard, lift it over the mailbox and up the stairs. Then we had to tilt it diagonally to fit through the front doors. After moving about 20 of them, I said, I can't move another one.

LINDA GUÉ: A flat-bed truck drove into the parking lot with a huge A-frame support for the glass. It was the largest shipment I had ever seen. He had 32 pieces all together. We had expected glass strips and now we saw we would need to hand-carry 8x8-foot squares of glass through the parking lot and around to the main entrance. I was always worried that someone would get hurt. Amazingly, nothing broke during the assembly or take-down.

FAE YAMAGUCHI: Soon after the Kadonaga and Valentine shows, I quit. I think I was burning out, and those two shows put me over the edge. Sometimes we risked our lives trying to hang paintings on the third floor over the stairwell. There was only a narrow ledge to stand on, and we'd edge out sideways with our backs against the wall.

LAILA TWIGG-SMITH (*note to Jane Arita, former Persis secretary, regarding* Tradition, American Style, *July 1976*): It is 2:30 am now, and we still have two walls to go, putting labels up, so I imagine we'll be here until 4 o'clock, which also means I won't be getting here too early… I can't believe this exhibit in terms of time. WOW. So, the point is, can you call Postal Instant Press on Kapiolani first thing in the morning to see if they have run that page yet and also changing from 197 pieces to 199—and 127 artists to 128? I hate to ask you to do this, but I really don't think I can be UP for it. The pizza will be $148 even, check to Pizza Hut. P. S. I was close: it's 4:30.

LAILA TWIGG-SMITH: I think *Tradition, American Style* was logistically the hardest show I've ever done. It was the Bicentennial show in July 1976. There were about 200 pieces, and they literally lined the gallery from floor to ceiling.

MARY MITSUDA: Ruth Tamura, the juror, accepted everything, so there was some really great stuff and some really terrible stuff. It was a very controversial show. The concept was to get the artists' impressions or statements about the spirit of America. Contemporary art is so American in concept. It's pushing the past, it's the frontier, it's the human condition. So it was wide-open and provocative; we had every response. In the end, it was a great concept and a terrific show.

THE HONOLULU ADVERTISER (*caption, January 26, 1977*): Well-known Hawaiian artist Juliette May Fraser puts the finishing touches to one of her wall panels that will go on display tonight at the Contemporary Arts Center in the News Building. To get just the right color for the flower she is working on, the artist brought down a cup-of-gold blossom from Manoa as a sample. Fraser, a longtime artist here, celebrates her 90th birthday today.

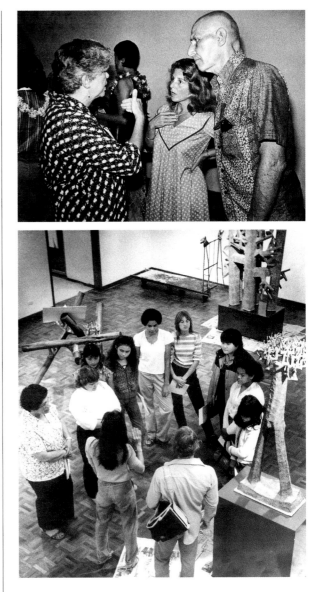

Top: Helen Gilbert and Caroline and Don Yacoe are among the guests at the opening of the John Barnett exhibition in June 1983.
Bottom: Satoru Abe's exhibition of sculptures in February 1982 draws a group of students to the Contemporary Arts Center.

Timothy Ojile and Roy Venters in the gallery before Venters' furniture, *You Can't Have One Without the Other*, and, on the wall, Ojile's *Still Life*. Their joint exhibition was held in March 1984.

LAILA TWIGG-SMITH: We had all kinds of shows, from paintings to murals to kites. In the Fraser show there was a 1938 masonite mural from San Francisco, 51 feet by 8 feet. One of the things that I did right away was to say to all artists having shows that they couldn't install their own work. They conceived it in their studios, so that's how they see it, on their walls. I thought of the Contemporary Arts Center as being my walls. I understand these walls: They're sixteen feet high, they've got the shelf, I know what the color is, I know where the lights are, I know where I can put things. I think artists get too close to their work in the studio.

JULIETTE MAY FRASER (*in exhibition brochure, January 26, 1977*): An artist must love walls to be a good muralist. Rapport must exist between a wall and its artist, for it is the wall which indicates what it wants and needs.

> THE HONOLULU ADVERTISER (*Ronn Ronck, December 10, 1981*): For an artist like George Peters, the sky is a wonderful place to be. Yesterday evening, Peters packed up his art and squeezed it into the News Building for the opening reception of "Air Show" at the Contemporary Arts Center. The exhibit takes its theme from the wind, air and atmosphere and features a skyfull of fanciful banners, sails, bridges, wings and kites. The display seems to have been born from within and grown outward to fill the room.

MARY MITSUDA: George Peters' show was an installation of kite-based forms that completely filled the gallery from ceiling to floor—a breathtaking cross between architectural engineering, mechanics, and a kind of silent music. He installed the show by himself in a few days. He would take these little rolled-up bundles that were like sections made of sticks and string and nylon fabric, rig them up and pull on some strings, and suddenly there was a 25-foot sky bridge across the room. And before you knew it, you were surrounded by all these arcs and wings and bridges, but they seemed as if they were made of light and air. I think it was one of the few shows that everyone loved. Generally, we got much more varied response, especially if the shows had any connection with sex, God and Country, or dead animals. Wow. I still find it amazing that a single room had such an effect on so many people. We'd get phone calls, letters, petitions—everything from excitement and enthusiasm to real outrage. As well as "ho-hum, this is it? They used more blood at the Biennale." It's to be expected: all those questions about who has the right to do something, show something, and what about the right of the public not to see something, to prevent their children from seeing it. What is pushing the boundaries, what is healthy, what is morally vile, what is self-indulgence, what is necessary exploration, what is confronting painful issues, and what is exploitation and easy shock

value. The same questions that will probably be asked forever, the questions that every society has to go through asking and answering every minute.

ROY VENTERS: I've always thought that, next to torture, art convinces the quickest.

> THE HONOLULU ADVERTISER (*Marcia Morse, March 25, 1990*): "Bad Art" is more a diversion than an artistic statement… Perhaps the most sane perspective at this point is to perceive the exhibition ("Bad Art") as a performance or ritual enacted periodically by artists (especially the younger ones) as a diversion from the struggles of sustained creative work. Ironically, petitions of censure (framed and incorporated into the exhibition) are symptoms of innocence. One wants to say, "You ain't seen nothin' yet."

SHARON TWIGG-SMITH (in a letter to News Building employees, March 1990): In light of the current exhibit, it is important to read the artists' statements and understand both the seriousness and the 'spoof' quality of what they are trying to do. The university is ultimately trying to get students to think about what good art is. Making bad art is another way of emphasizing that idea. I am sympathetic to the concerns for children; however, I believe they see this and much much worse on TV every day…

LINDA IVERSON (*former Human Resources manager, Hawai'i Newspaper Agency, who conducted tours*): Some of it was really bad. Some of it was gross. The main piece in the middle of the gallery was a soft sculpture and a hard sculpture that depicted an asphalt portion of a roadway, the black top, with skid marks, and in the middle of it was a soft-sculpture dead dog, with tread marks over it. There was blood. The exhibit went up over the weekend. On Monday morning, when it was up and ready, I walked in and there was someone screaming. Her dog had gotten killed over the weekend. She walked into the gallery and freaked out. Everyone started coming down and looking at this. People were covering the dog with a towel, and then the towel would disappear. They circulated a petition. Sharon had it framed and put it in the middle of the entranceway. It was really interactive.

SHARON TWIGG-SMITH: I felt that being uncomfortable around art was not a bad thing. If the art in the gallery wasn't challenging, we weren't doing our job. We had several interesting altercations with employees over this exhibit. The content made some of our employees so angry that, for a year, long after the exhibit was taken down, I had to deal with their anger. I'd frame and put up their petitions as part of the exhibit; it just made them madder. The art brought out things in people that I didn't think were possible. One employee came up to my office to complain about the inappropriateness of

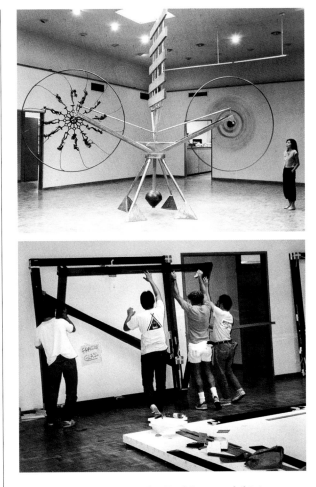

Top: The Fred Roster exhibit in October 1984.
Bottom: DeWain Valentine's exhibition in January 1985.

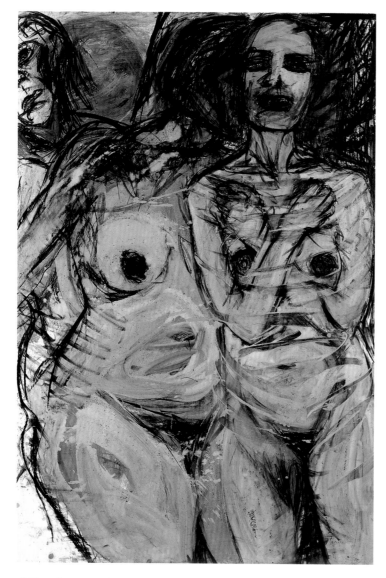

Mira Cantor: CONVERSATION 13, *charcoal, gouache, 1984* David Bates: THE JETTY FISHERMAN, *mixed media, 1990*

Dorothy A. Faison: INSTINCT CROSSING, *oil, acrylic, pastel, charcoal, 1990*

Toshiko Takaezu: UNTITLED, *ceramic, 1987* Lucille Cooper: WARRIOR VESSEL NO.2, *ceramic, 1984*

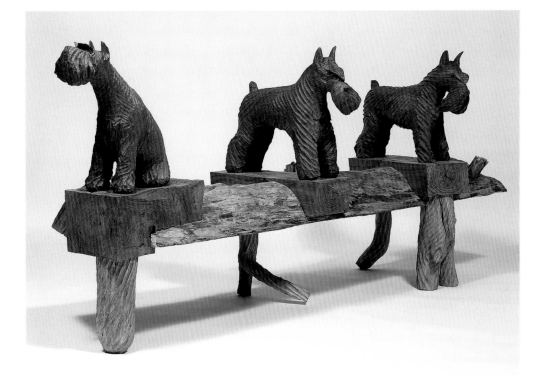

Fred Roster: JAX 1/5, *bronze, 1989*

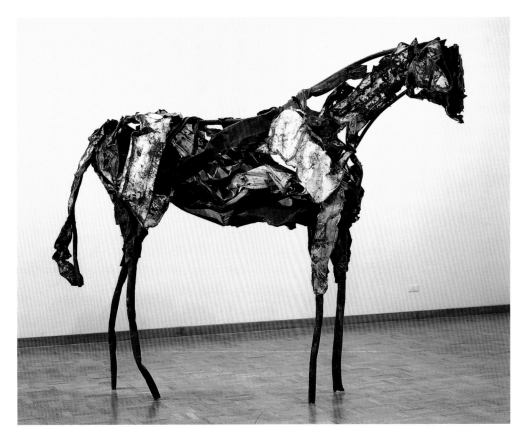

Deborah Butterfield: No. 2 - 86 (MOKULELE), *metal, 1986*

H.C. Westermann: A Crash in the Jungle, *ink and watercolor on paper, 1973*

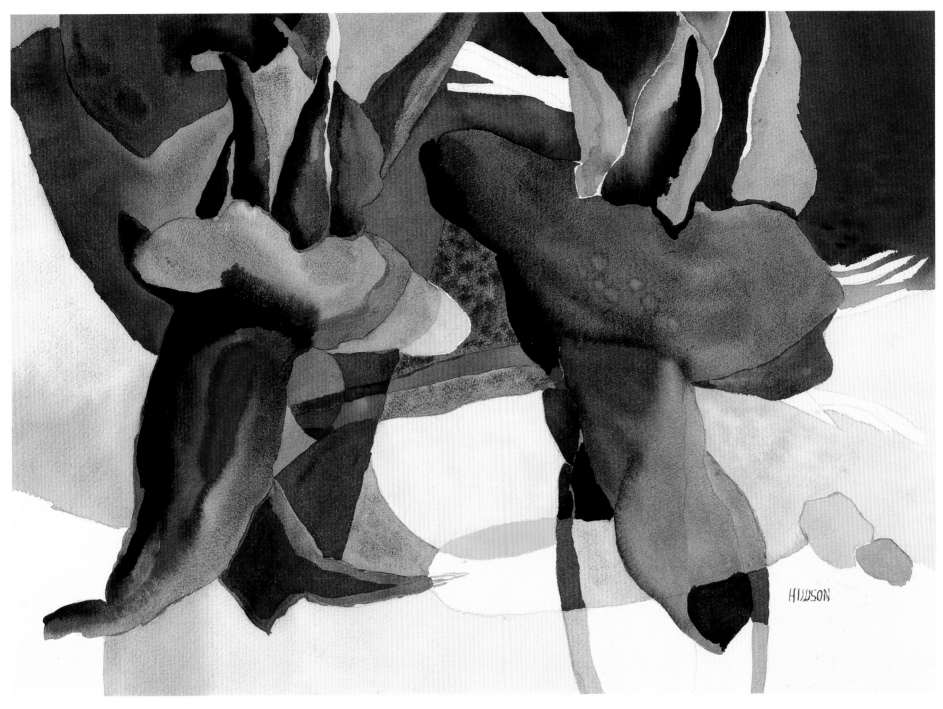

Winnifred Hudson: TREES IN LIMBO, *watercolor, 1981*

Bruce Conner: BOOK PAGES, *felt tip watercolor pen on paper*, 1967

Don Dugal: Overpass, *sepia/mixed on paper,* 1983

Vito Acconci: Wav(er)ing Flag, *3-color lithograph, 1990*

Doug Young: SUI SAN SERIES: AHI #1, *watercolor, 1983*

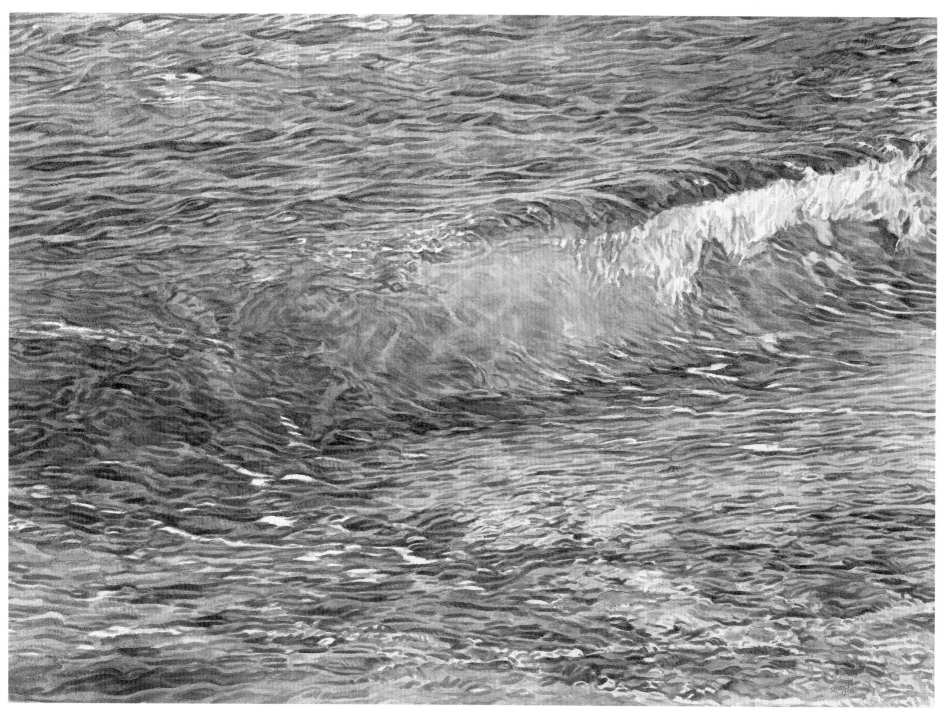

Jonathan Busse: BREAKING, *watercolor, 1988*

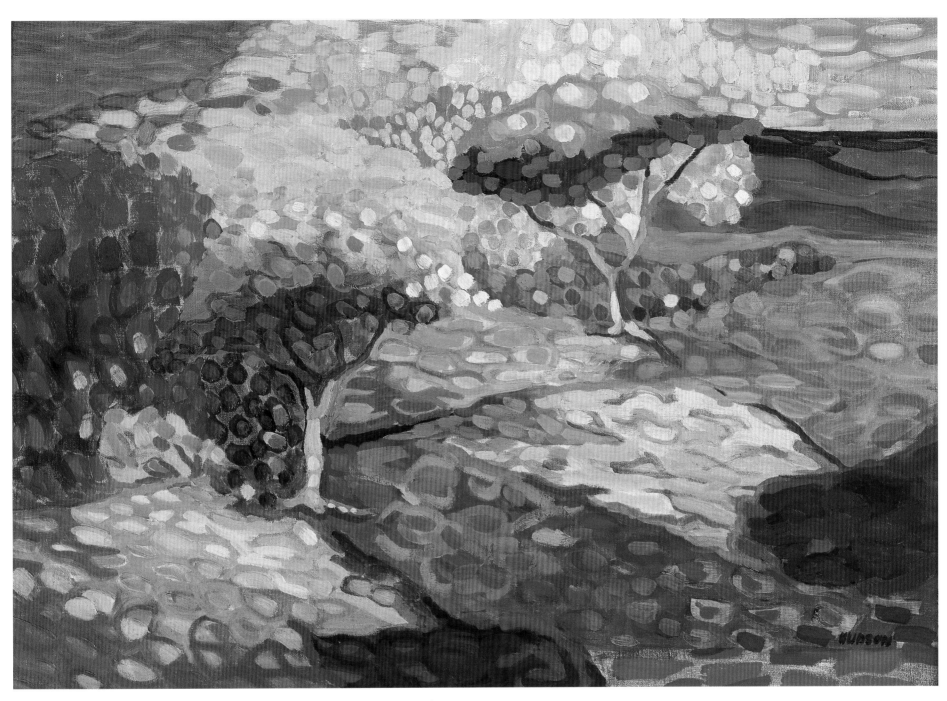

Winnifred Hudson: Hᴀᴡᴀɪɪᴀɴ Lɪɢʜᴛ, *oil, 1969*

Viewers contemplate Betty Rodger's
Invitation for a Dream, mixed media,
at a June 1984 exhibition.

a picture depicting a horse fornicating with a man. I hadn't even seen it and asked her to show it to me. It turned out to be a minuscule part of a complex piece that you practically needed a magnifying glass to see. Can you imagine spending the time it would take to find that item in an exhibit you don't even like? The ironies were endless. I would come around a corner unexpectedly, and a crowd of chattering employees would suddenly go silent. For a long time, I felt like a pariah.

LINDA IVERSON: Some of the photography was absolutely gorgeous. There was some snickering from the puberty kids, the nudging with the elbows. I asked them, "What is your favorite picture?" We got them talking about it, and it was a wonderful opportunity for all age groups to see contemporary art and experience it regardless of their own personal preference. It's okay not to like some art. That's human nature.

ROY VENTERS: I like the shows that took chances. Most of the memorable shows were memorable because they had taken a chance, gone in another direction.

> HONOLULU STAR-BULLETIN *(Jean Charlot, March 3, 1971)*: Mira Cantor looks squarely at the model, and does so with unflinching attention. Every one of her drawings and intaglio prints is based on the science of anatomy. Strong as her work is, unflinching as may be her anatomical renderings, the spirit that informs Mira Cantor's work is surprisingly delicate and even hesitant in its emotional statements.

MIRA CANTOR *(artist)*: I always force art down people's throats by bringing it to public places, because I feel that few people have the opportunity, knowledge or desire to look at art, and many have a fear of entering museums. So the way to do it is to present art in public places. My show at the center was in 1971, one year after I arrived in the Islands for my first job out of graduate school, teaching at the University of Hawai'i. My work was always figurative, always with the focus on human anatomy and gender. Jack Newton saw my work and offered me the first exhibition of his tenure at the Advertiser Gallery. People had to literally walk through the gallery to get to their work stations. There was no question about my work until it went on the walls and the women started to become very offended by the male nudes, male genitals. My work was based on classicism: isolated figures exposing the truth about the human form. It wasn't a big deal, but it was probably a shock to what the majority of people in Hawai'i were used to seeing, which at the time was generally decorative or abstract. But I was from the Northeast, and my work had strong expressionist feelings.

Some of the reviews couldn't understand why people were so furious. Had the gallery

not been a public place, there would not have been that response. Twigg came to my rescue. He posted a letter in my defense. I was impressed by that, because he could have done what other publishers or editors would have done. He could have said, "I don't want to offend my employees."

THURSTON TWIGG-SMITH (*in a letter to Friends of the Arts Center, March 1, 1971*): The question raised about this show concerns taste. Those critical think it is in bad taste. Those with a strong art background dispute this. Fully conceding each individual's right to determine his own dimensions of taste, is it too much to suggest that there may be some validity in this show that those critical of it are overlooking? If the intention of the artist, Mira Cantor, were to draw pornographically, that would be one thing. But it is not; she finds in the human form the beauty that another artist might find in seascapes or way-out abstracts, or whatever. This show will be controversial. But that is a valuable part of art. By all means, join in the controversy.

SHARON TWIGG-SMITH (*in a letter to News Building employees, March 1990*): I see the corporate art collection and the gallery space as having wonderful potential for doing what contemporary art does best: stretching our minds, making us think, forcing us to come up with new and different solutions to the same old problems, and being creative human beings. That's why contemporary art in the workplace is such a positive influence.

> THE HONOLULU ADVERTISER (*Bob Krauss, April 5, 1998*): I was amazed how my attitude toward art changed. Things I liked at first sight became trite. A piece that I first thought absurd began to take on deeper meaning. Another surprise was finding out how much my fellow workers liked this stuff. So the art gallery helped us appreciate each other more. More important, it made us different. Nobody else had an art gallery. We were proud of that.

SHARON TWIGG-SMITH: Most corporate collections are in environments that, by nature, separate the employees from art. Ours is in the News Building. We don't have a pristine, sanitized building. Here's the art on the wall, over your head, hanging from the stairwell; it's all over the place. There's also a confidence that has grown in the dynamic between the employees and the art in the building. It's a unique situation. We believe that art is a necessity. It makes people think.

ROY VENTERS: Art may be a luxury because most of the time it's so expensive. But even people without money can enjoy art because of this collection. They can walk into the News Building and have a wonderful experience with this art. One of the many

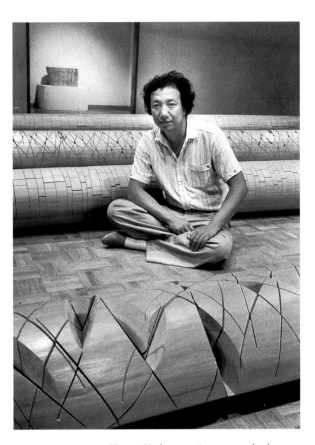

Kazuo Kadonaga sits among the log sculptures sent from Japan for his exhibit at the CAC in November 1984.

83

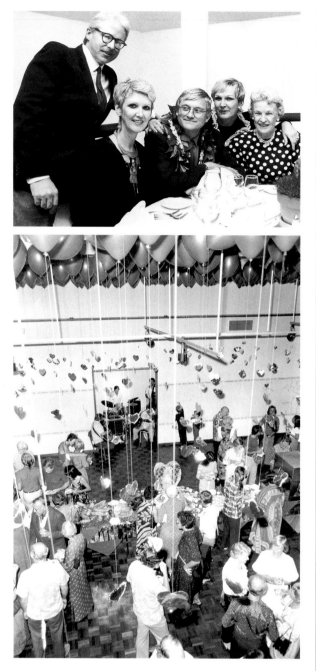

Top: From left, Fritz Frauchiger, Sharon Twigg-Smith, David Hockney, Laila Twigg-Smith, and Lila Morgan share a moment during the Hockney opening at TCM in February 1990.

Bottom: Silver hearts dangle from red helium balloons at the first anniversary of LARC, Lovers of the Arts Center, at the Contemporary Arts Center on November 9, 1991. Hundreds of art lovers arrived to show their support.

things this collection has accomplished is that it has changed the lives of those who have been forced to work in the presence of art. Even today, you can see what the struggle has yielded. People walk through that gallery and see art work that is quite extreme. In the early days they complained, because they thought someone was trying to put something over on them. Because the art was in their daily work environment, they had to come to terms with it, and it broadened their minds. You may not want young kids to come in and put graffiti on public spaces, but the obligation to the community is greater than that. Risk or not, space for art should be open to the community. If it changes even one person's life out of a group of ten teenagers, that is art's role.

DANA MOREY (*telephone operator, Hawai'i Newspaper Agency, about a Hank Murta Adams glass sculpture*): Do you know what that is? It's a melted condom on a penis, looking like a face with a hat.

LINDA IVERSON: I feel fortunate that I had the opportunity to wander around the building at random. I'd take visiting groups upstairs, through the *Advertiser* and *Star-Bulletin* newsrooms, and we'd get to see the pages made up, writers writing, on the phone, machines buzzing—the hustle-and-bustle of getting the paper out. Now it's different because there's so much use of the computer, but prior to that, it was hands-on work. There were noises, smells, sights; visitors had to wear earplugs. And there was art, everywhere, in the gallery and in the newsrooms. We received a lot of thank-you letters.

JAMES JENSEN (*associate director, chief curator, The Contemporary Museum*): One of the first projects I had after I came to this museum in April, 1991, was the thirtieth anniversary of the Advertiser Gallery exhibition. I remember specifically that it opened on October 9. I had changed residences on October 1 and I was in the midst of the chaos of moving. From a list of exhibitions of the past thirty years, we invited all artists who had ever shown to participate in a group exhibition that would celebrate the thirtieth anniversary. Just about everyone responded positively. I guess I wasn't really thinking about the logistics and the response. I had a lot of studio visits to make. I was exhausted from the upheaval of moving and running around to so many studios, and a bit discouraged, worrying about whether the show was going to come off. Then all this work started pouring in. It was stacked around the Advertiser Gallery. It hit me: How are you going to make sense of this? How are you going to install this? I went in at about 4 o'clock on a Sunday evening. I walked into that gallery and sat on a chair in the

middle of it and thought, oh my god, you've really done it this time, you're in over your head. One hundred twenty one artists had submitted works of all different kinds and sizes. Wall by wall, piece by piece, I went through the work. I tried to separate it into groups and laid it out on the floor. You could barely move around in the gallery. I started playing with the pieces on the floor, making arrangements, like a puzzle. Then I put everything back against the wall so that people arriving in the morning would be able to walk through. I was there until midnight. In the end, it turned out to be a great exhibition, a wonderful celebration. Thirty years were condensed into a couple of months and it was a remarkable learning experience. I became keenly aware of how many artists had been served by the Contemporary Arts Center, and how important it was to all of them, and to the arts scene here in general.

Top: Baba's Door by Tony Berlant, a gift of the Watumull Foundation, can be seen at TCM.

Middle: Arnold Zimmerman's untitled stoneware sculpture, 1985, is a central feature of TCM's garden environment.

Bottom: A view inside The Contemporary Café, a popular spot for lunch and art.

James Surls: MALE FIGURE, *oak, pine and steel, 1989*

Sean Scully: MAKE LIGHT, *oil on canvas, 1985*

Vernon Fisher: Illustrations for a Story
oil/blackboard on wood, 1996

Jon Hamblin: City Gone Wild, AP
linocut, 1984

Squeak Carnwath: Reasons
oil and alkyd on canvas, 1991

Gaye Chan: Prophets, Net & Gross
wood, paper, acrylic, chalk, pastel, hot glue, 1989

Mark Bulwinkle:
OH WHY DON'T YOU ALL JUST DROP DEAD DOG
silkscreen on board, 1974

Wayne Levin:
UNTITLED
black and white photograph, 1983-84

Mary Mitsuda: OPEN OCEAN
acrylic on canvas, 1995

Hiroki Morinoue: SURFACE OF ROCKS
watercolor, 1977

Mamoru Sato: SCAPE 87-5, *aluminum, steel, lead, 1987*

Michael Tom: FADING IMAGES, *bronze, slate, 1989*

Vicky Chock: PARADOX, *clay, 1996*

Bruce Cohen: UNTITLED, *oil on canvas,* 1987

Carolyn Brady: SOUVENIR OF PARIS/CAFÉ AU LAIT, *watercolor on paper,* 1991

Good-Bye

Top: Viewers admire a piece by the late Laila Twigg-Smith and, at left, photographs by Franco Salmoiraghi, taken in 1983.

Middle: Salmoiraghi's photos draw viewers of all ages at *So Long Salon.*

Bottom: Georgianna Lagoria, director of The Contemporary Museum, and Thurston Twigg-Smith at *So Long Salon.*

JAMES JENSEN: More than 130 artists responded to the invitation to contribute a work to the final exhibition of the Advertiser Gallery, *So Long Salon*, in March, 1998. The energy, the sense of community at the event, was thrilling. It was a fitting way to end a very important exhibition program which lasted over thirty-six years.

GEORGIANNA LAGORIA (*director, The Contemporary Museum*): It was a unique event. While it celebrated the end of something, there was so much energy that it pointed to the future. More than 800 people attended. The gallery was rooted in the fact that there was an artistic energy in the community, and it needed a center. *So Long Salon* made it clear that the energy is still there, that the people are still there, they're still working, their work is vital, and their numbers have grown. There were artists there straight out of school, and others who had been around for decades. The great majority of the people who were there were artists. They came out for each other, and that was the whole point of the gallery. In a commercial gallery, you have to worry about how saleable a work is. In the Advertiser Gallery, the last thing artists had to worry about was how saleable their work was. When you're free of that concern, you do your best work. And that's what the Advertiser Gallery was. It was a white box where artists could be free. They could do performances, installations, theme shows, paintings, sculpture. We need that kind of freedom, an editorial freedom. It was in a news building, where freedom of speech is a given. Art was protected under that shield. As director of a museum, I would like to translate that into what the museum has to offer, to make that a part of who were are. I do think that quality is transferable. It's an attitude on the part of the artist and the institution. It's like a pact.

JAMES JENSEN: I guess you could say that the Persis Collection is making a transition. It is going from a private corporate collection into the public domain. It can be very frustrating for me sometimes. My responsibility is to look out for the interests of this museum and this community. I feel deeply committed to this community, and I want Hawai'i to have great contemporary art because it is geographically so isolated. I don't see another opportunity on the horizon where there will be an individual or entity with the resources or commitment of Persis. What is happening with the collection is tremendously important for The Contemporary Museum, for the community. In my

mind, it's crucial that important collections, important works of art, go into museums like ours, where they can be combined with other collections and generate further dialogue, becoming an educational resource for everyone to use and enjoy.

THURSTON TWIGG-SMITH: We've made big gifts to Yale and the Whitney and other institutions, and that will continue. In keeping with our philosophy of giving back to the community, we also hope to keep as much of the collection as possible here in Hawai'i . I've become quite attached to the collection, but at the same time I've quite adjusted to seeing it go into museums. Sharon and I have done that with our own things.

ALLYN BROMLEY: When artists no longer find public support for what they're doing, there is a danger that they will create according to corporate tastes. Corporations have to be awfully careful about what kind of art is bought to represent American art. They have different goals from museums; their tastes can be personal and conservative. Art has taken such a conceptual direction since the 1980s that collecting on a comprehensive scale can be difficult. Curating is a challenge even for museums, whose mandates are more comprehensive than those of corporations. Performance pieces, video art, much of the conceptual or socio-political issues of the '80s and '90s are not only difficult to curate, but difficult to relate to. Much of the new art is in a format not to be hung or exhibited in ways of the past.

ALAN LEITNER: I feel that this is the final chapter of the development of the modern art community in Hawai'i, a history and legacy of not just individuals, but rather periods of time and institutions. It makes me very, very sad to see the Advertiser Gallery close. Some of the greatest memories of my life are in that building.

GEORGIANNA LAGORIA: Now it's up to the artists. By that I mean that it is the artists' responsibility to do their best work, with or without institutions. It's the artist and the artwork that's most important; the institutions are there to support that freedom. The strength, the energy, has to come from the artist.

SHARON TWIGG-SMITH: I want people to know what happened here. Since 1961, the collection and the gallery have had a profound influence on artists. Emerging artists should know that this can happen again. Those of us who lived through it know that it has changed us forever.

Top: An art lover at *So Long Salon* views the gallery from above.
Middle: Timothy Ojile, Yvonne Cheng, Jocelyn Fujii, Sharon Twigg-Smith and Roy Venters at *So Long Salon.*
Bottom: Dan Rudoy and Franco Salmoiraghi at *So Long Salon.*

Christopher Brown: SKATERS, *oil on canvas, 1989*

Darren Waterston: MAYA, *oil on canvas over panel, 1995*

Tadashi Sato: Surf and Leaf
oil on canvas board, 1991

Lloyd Sexton: Ferns - Volcano Area
oil on canvas, 1990

Roy Venters: SHRINE TO SELF, *assemblage,* 1990

Keichi Kimura: DEBRIS, *oil on canvas, 1981*

Joseph Raffael: ISLAND MAGIC, *oil on canvas, 1975*

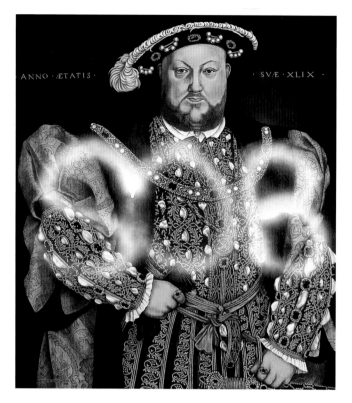

Barbara Drewa: THE SURROGATE
oil on masonite, 1984

Joan Brown: BUFFALO IN GOLDEN GATE PARK
oil on canvas, 1967-68

Robert Arneson:
SPECIAL ASSISTANT TO THE PRESIDENT
acrylic, plastic enamel, oil on canvas, 1989

Robert Arneson: HUMMMM
cast paper, 1981

Allyn Bromley: DÉNOUEMENT I, *wood and embossed lead, 1983*

Judith Shea: STUDY 1990-93 (MASCULINE), *ink, gouache, graphite on paper, 1990-93*

David Hockney: ROYAL HAWAIIAN HOTEL, *colored pencil, 1971*

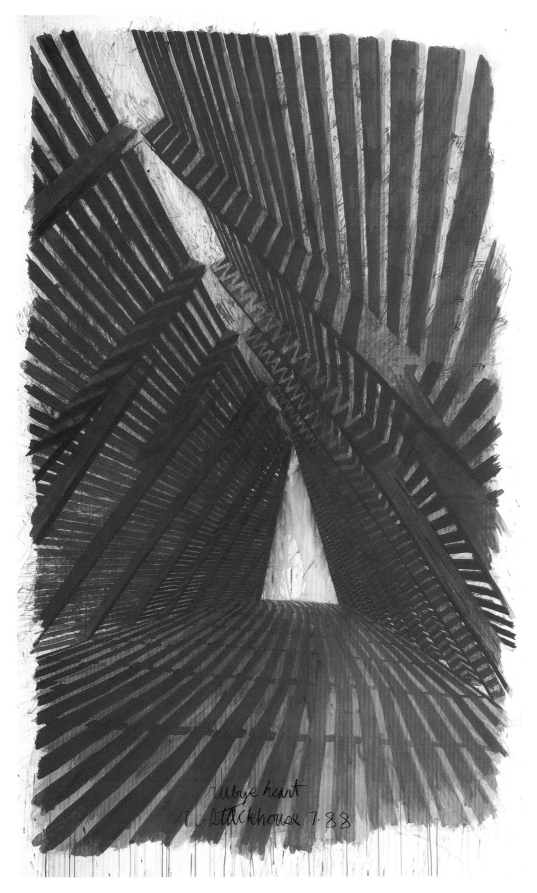

Robert Stackhouse: RUBY'S HEART, *watercolor and charcoal on paper mounted to linen, 1988*

Acknowledgments

Deepest appreciation is extended to all those who contributed time, thoughts, laughter, affection, wit, insight, and considerable powers of recollection to the making of this book. Like the early exhibitions at The Honolulu Advertiser Gallery, this book is "pot luck"—a collective effort, a mosaic of thoughts and words that reflect the true nature of collaboration.

Mahalo to Mary Mitsuda, Roy Venters, Fae Yamaguchi, Linda Gué, Allyn Bromley, Georgianna Lagoria, Alan Leitner, Allison Wong, Anne Smoke, Stephie L'Heureux, Don Dugal, Helen Gilbert, David Yamada, Loraine Pang, Linda Iverson, Jolene Taga, Pat Fong, Yvonne Cheng, Doug Young, Violet Yap, Carol Hasegawa, Mira Cantor, Denise DeVone, Catherine Wheeler, Dana Morey, George Adams, Sique Spence, Paris Kim, Grady Timmons, Joyce Libby, B.J. Taum, Corey Sumida and Denise Shinkawa for their contributions to this effort. A special mahalo is extended to the more than 700 artists who are represented in the Persis Collection, and to all those whose work was featured in the 37 years of exhibitions at the News Building. We regret that it was not possible to represent all of them on these pages.

As always in matters of art, Jay Jensen's keen insights and attention to detail proved invaluable from start to finish. We are all the beneficiaries of his encyclopedic knowledge of Hawai`i's art history and his commitment to this community. Many thanks for his generous spirit, from helping with the broad strokes of constructing this book to the minutiae of lists, proofs, and corrections.

The look and form of this book are the work of Bud Linschoten, a designer of unflappable nature and magnamimous heart. It was not easy to contain, between the two covers

List of Artists

Berenice Abbott
Satoru Abe
Yasuko Abeshima
Mark Abildgaard
Vito Acconci
Hank Murta Adams
Suzanne Adan
Sister Adele
Nicholas Africano
Lorenzo Agngarayngay
John Ahearn
Shizuka Akiyama
Garron Alexander
John Alexander
Peter Alexander
Terry Allen
Carlos Almaraz
Peter Almeida
Dr. Theodore Althausen
Gregory Amenoff
Joseph Andoe
Richard Anuszkiewicz
Robert Arneson
Charles Arnoldi
Evan Asato
David Asherman
Milton Avery

Thomas Bacher
John Bade
Clayton Bailey
William Bailey
Richard Baker
Ray Jerome Baker
Bunky Bakutis
Jim Barnaby
John Barnett
Charles Bartlett
Jennifer Bartlett
Jean-Michel Basquiat
David Bates
Robert Beauchamp
Joan Beaumont
Frank Beaver
August Becker

Richard Beerhorst
Larry Bell
Mary Bell
Billy Al Bengston
Carol Bennett
Tony Berlant
Timothy Berry
Les Biller
Debra Bloomfield
Mary Bonic
Jean Boone
Derek Boshier
Richard Bosman
Gregory Botts
Boyd Wreath Studio
Carolyn Brady
Robert Brady
Reiko Mochinaga Brandon
Fred Brathwaite
Shore Brenner
Karen Breschi
Dwight Bridges
Barbara Britts
Allyn Bromley
Pegan Brooke
Judy Brooks
Christopher Brown
Joan Brown
Roger Brown
Theophilus Brown
Sean Browne
Edward Brownlee
Mark Bryce
John Buck
I Made Budi
Mark Bulwinkle
Robert Bush
Ken Bushnell
Jonathan Busse
Deborah Butterfield

Helene Cailliet
Lawrence Calcagno
Roger Campbell
Steven Campbell
Mira Cantor

Michael Cantrell
Suzanne Caporael
Squeak Carnwath
Fredrica Cassiday
Pat Catlett
Vija Celmins
Gaye Chan
Carolyn Chang
Douglas Char
Lam Oi Char
Peter Charles
Jean Charlot
Martin Charlot
Louisa Chase
May Chee
Wendy Kim Chee
Yvonne Cheng
Lee Chesney
Jack Chevalier
Brenda May Ching
Dennis Ching
Teresa Ching
Wong Ching
Vicky Chock
Myung Ae Choi
Jesse M. Christensen
Lau Chun
Chuck Close
Bruce Cohen
Larry Cohen
S.E. Coleman
Robert Colescott
D. Collum
Clyde Connell
Bruce Conner
Cynthia Conrad
Richard A. Cooke III
Lucille Cooper
George Cope
John Coplans
Steve Correia
Lucy Corrigan
Christina Cowan
J. Halley Cox
Willa Cox
Robert Craner
Noche Crist

Robert Cumming
Tom Czarnopys

J.N. "Ding" Darling
Ward Davenny
Russell Davidson
David Davis
Palli Davene Davis
Ernest DeCoito
Roy De Forest
Jon de Mello
Vincent Desiderio
Denise DeVone
Robert Dick
Laddie John Dill
Jim Dine
Mark di Suvero
Douglas Doi
Isami Doi
Stephen Doi
James Doolin
Susanne Doremus
Peter Drake
Barbara Drewa
Don Dugal
Jeffrey Dunn

Julia Eastberg
P.S. Ebert
Don Eddy
Pamela Eliashof
Raymon Elozua
Arthur Emerson
Barbara Engle
Steve Engle
Bruce Erickson
Martha Mayer Erlebacher
Richard Estes
Kathy Everett
Margaret Ezekiel

Dorothy A. Faison
Dennis Farber
Howard Farrant
Joseph Feher
Sandi Fellman

Nadine Ferraro
Carl Fieber
James Finnegan
Eric Fischl
Janet Fish
Charles Fisher
Vernon Fisher
Anita Fisk
Doug Flackman
Elsa Flores
Ka-Ning Fong
Patricia Tobacco Forrester
Clare Forster
Mimi Foster
Llyn Foulkes
Sam Francis
Sara Frankel
Juliette May Fraser
Jane Freilicher
Bob Freimark
Viola Frey
Helen Mary Friend
Richard Frooman
Minnie Fujita
Jane Wyatt Fullerton

Sally Gall
Charles Garabedian
Ron Genta
Jill Giegerich
Gil Gilbert
Helen Gilbert
Jonelle Gillette
Joan Gima
Lawrence Gipe
Andy Goldsworthy
Carmen Good
James Goodman
R.C. Gorman
James Goss
Byron Goto
Joseph Goto
Peter Gourfain
Robert Graham
David Graves
Nancy Graves

Robert Greene
Michael Gregory
Scott Greiger
Franz Griessler
Red Grooms
Nancy Grossman
Linda Gué

Francis Haar
Tom Haar
Elizabeth Habermann
Nina Hagiwara
Julie Halpern
Jon Hamblin
Jane Hammond
Joe Hampton
Michele Hamrick
Raymond Han
Ione Haney
Gaylen Hansen
Susan McGovney Hansen
Dennis Hanshew
Duane Hanson
Michael Harada
James Harmon
Donald Harvey
Shirley Hasenyager
Joseph Haske
William Hawkins
Stanley Hayase
Richard Hayashida
Peter Hayward
Hon-Chew Hee
Julie Heffernan
Milan Heger
Jack Heintz
Al Held
Gerard Henderson
Maxwell Hendler
Edward Lamson Henry
Sam Hernandez
Nanci Hersh
Peter Hess
Hewitson

Charles Higa
Kaoru Higa
Jene Highstein
Raymond K. Higuchi
David Howard Hitchcock
David Hockney
Wade Hoefer
Laurie Hogin
Randy Hokushin
Tom Holland
Honolulu Printmakers
Pegge Hopper
Claude Horan
Allen Hori
Lois Horne
W.B. Hoyt
Winnifred Hudson
Richard Hull
Stephen Huneck
Bryan Hunt
Patricia Hunter
Peter Hurd

Ken Ibaraki
Jim Iinuma
George Ikinaga
Gerald Immonen
Bill Irwin
Brian Isobe
Reika Iwami
Ralph Iwamoto

Barbara Jackson
Joel Janowitz
Gay Jefferson
Hugh Jenkins
Ibby Jenkins
Neil Jenney
Karen Jennings
Tom Jennings
Kenneth Josephson
Jasper Johns
Bruce Johnson
Arthur Jones
David Jones

of a book, the history of such an eclectic collection and the work of so many artists. Bud's creative contribution to this book is immeasurable.

At the beginning and end of this story are the Twigg-Smiths. Twigg, whose initial, unhesitating nod first made possible the gallery and collection, also made this book possible. Laila's enthusiasm put contemporary art in Hawai'i on its unstoppable course. To them, and to Sharon, we owe an enormous debt of gratitude for creating what is now one of Hawaii's premier cultural resources. I wish to thank, especially, Sharon Twigg-Smith. This book is her brainchild, and it was she who shepherded it from the first vague stirrings of an idea to a story on the printed page. As curator, she has had a profound influence on the substance and direction of the collection. She shared her knowledge unconditionally and persevered valiantly when the going got tough. As a friend and collaborator, she is peerless.

To my chief supporter and unofficial editor, Brad Shields: grace, always.

Jocelyn Fujii

Photo Credits

Dana Edmunds:
8, 10, 12, 13, 17, 18, 21, 22, 23 top, 26, 28, 31, 33, 34, 35, 36, 38, 39, 40 left, 41, 42 top left, bottom left and right, 48, 49, 50 right, 51, 52, 56, 58, 62, 64 top, 65, 70 left, 71, 72, 74, 75, 78, 79, 80, 81, 88, 89 right, 90,91, 92, 93 top, 97, 98, 99, 100, 101, 102 right, 104, 105, 107

Paul Kodama:
37, 40 right, 42 top right, 50 left, 53, 63, 64 bottom, 70 right, 73, 77, 85 top, 86, 89 left, 93 bottom, 96, 102 left, 103, 106

Brian Reed:
94, 95, 110, 111

William Waterfall:
85 center and bottom

Courtesy of The Honolulu Advertiser:
9 top, staff; bottom, T. Umeda
11 Charles Okamura
14 staff
15 top, Pipi Wakayama
16 top, Charles Okamura; bottom, T. Umeda
25 top, T. Umeda
27 top, Jerry Y. Chong
29 top and bottom, T. Umeda; center, Roy Ito

30 Kenneth K. Kuwahara
32 bottom, Roy Ito
43 Art Otremba
44 staff
45 Art Otremba
46 Roy Ito
54 top, Roy Ito; bottom, Charles Okamura
55 T. Umeda
66 top, staff; bottom, T. Umeda
67 bottom, staff
68 Carl Viti
82 Carl Viti
84 bottom, Ron Jett

Courtesy of The Contemporary Museum:
2-3, 25 bottom
27 bottom, Roy Ito
57 Roy Ito
59 top and bottom
67 top
69 top, Gregory Yamamoto; bottom, staff

83 T. Umeda
84 top

Courtesy of:

Ken Bushnell
15 bottom, Francis Haar
Don Dugal:
47 top and bottom
Helen Gilbert:
32 top, Francis Haar
John Berggruen Gallery, San Francisco:
20, 60, 61
Frumkin/Adams Gallery, New York:
19, 24
Michael Kohn Gallery, Santa Monica: 76
Roberta Lieberman Gallery, Chicago:
23 bottom
L.A. Louver Gallery, Los Angeles: 53
David McKee Gallery, New York: 87